POSTCARD HISTORY SERIES

Eastern Montgomery
County Revisited

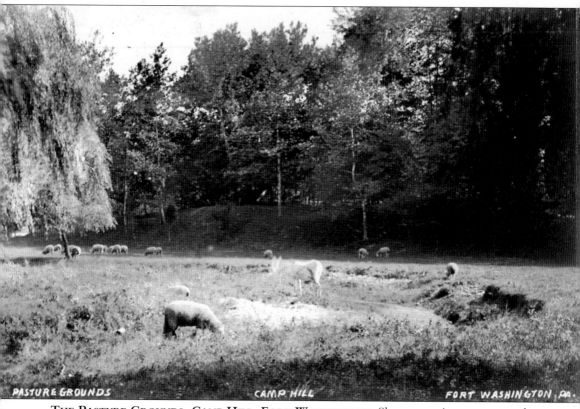

THE PASTURE GROUNDS, CAMP HILL, FORT WASHINGTON. Sheep graze in an open meadow near Camp Hill in Fort Washington *c.* 1908. Until the mid-1900s, much of Montgomery County was very rural and comprised of many farms. This William Sliker postcard view reflects the rural nature of this area during that time period.

POSTCARD HISTORY SERIES

Eastern Montgomery County Revisited

Andrew Mark Herman

ARCADIA

Published by Arcadia Publishing
Charleston SC, Chicago IL, Portsmouth NH, San Francisco CA

Printed in Great Britain

Library of Congress Catalog Card Number: 2005924671

For all general information contact Arcadia Publishing at:
Telephone 843-853-2070
Fax 843-853-0044
E-mail sales@arcadiapublishing.com
For customer service and orders:
Toll-Free 1-888-313-2665

Visit us on the Internet at http://www.arcadiapublishing.com

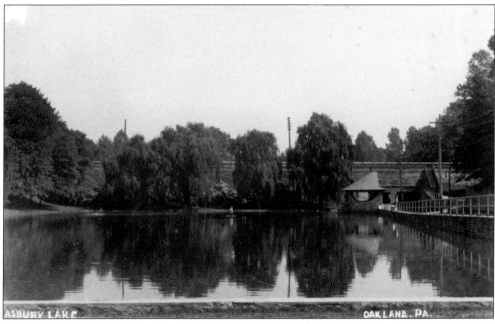

ASBURY LAKE, OAK LANE. A bit of vanished landscape is illustrated in this 1908 Sliker postcard view of Asbury Lake on the Thomas Henry Asbury estate grounds, located along Cheltenham Avenue in Cheltenham Township. The lake was a feature on the property from the latter half of the 19th century to the 1920s.

CONTENTS

ACKNOWLEDGMENTS

My sincere thanks and appreciation go to the following individuals, who provided assistance with material pertaining to this book: Buck Amey, Claudia Herman, Bob Moyer, Henry Scholz, Pat Stopper, David Rowland, and Bob Whittock.

This book is dedicated to my family—Claudia, Lauren, Ali, Maddie, Marvin and Paula Herman and Robin Moskovitz—and in memory of two individuals who cherished Montgomery County history, Michael E. McGlynn (1952–2003) and Stephen Silverman (1951–2004).

INTRODUCTION

Montgomery County, Pennsylvania, was incorporated in 1784, but much of the area was first settled in the late 1600s and early 1700s. Originally part of Philadelphia County, early settlements were mostly small villages, farms, and a few larger towns. Most of eastern Montgomery County was inhabited by Quakers, as evidenced by early Friends meetinghouses established in Abington, Merion, Horsham, Upper Dublin, Plymouth, and Gwynedd. Other religious groups joined the Quakers thanks to the religious tolerance established by Pennsylvania's founder, William Penn.

The physical geography of Montgomery County greatly influenced the development of the area. The county's location immediately north of Philadelphia ensured that the area would have a growing population. Numerous waterways, such as the Pennypack and Wissahickon Creeks and the Schuylkill River, spurred the development of mills. A vast network of roads and railroads greatly aided in transportation. And its gently rolling hills and fertile soil established the county as an agricultural and farming region for over two centuries.

This volume illustrates the early aspects of life in the eastern part of the county, which is generally described as the area south and east of present-day Route 202 (DeKalb Pike). The postcards on the following pages depict religious institutions, historic homes and farms, and the beautiful country scenery that once dominated the area. Also included in these images are hotels, stores, businesses, and street views of the many villages.

When the first photographic history of eastern Montgomery County was written in 1999, there were few books pertaining to this area. The images in this volume are completely different than those in the first book and are meant to provide a complementary representation of the wide diversity of life found in eastern Montgomery County.

The purpose of revisiting eastern Montgomery County is twofold. First, this book will revisit popular and familiar places like Willow Grove Park, Chestnut Hill Park, Valley Forge, the Main Line, and others. Second, this volume illustrates places not found in the first volume, including Barmouth Center Square, Cold Point, Dresher, Edge Hill, Gladwyne, Harmonville, Jarrettown, Lafayette Hill, McKinley, Narcissa, Port Kennedy, Valley Falls, Wyncote, and Wyndmoor. Together, this book and the first volume create a comprehensive illustrated study of eastern Montgomery County.

This book brings together two themes. First, of course, is the beautifully historic region, but second are the wonderful postcards that were photographed and published nearly a century ago. The postcards presented here are by well-documented local publishers, including John Bartholomew of Lansdale, W. W. Miller of North Wales, William Sliker of Philadelphia, Philip Moore of Germantown, and others. The mission of this book is to focus on the significance of our area and to highlight these publishers and their extraordinary images.

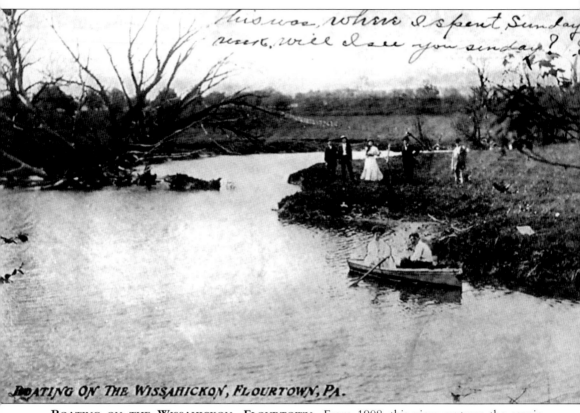

BOATING ON THE WISSAHICKON, FLOURTOWN, PA.

BOATING ON THE WISSAHICKON, FLOURTOWN. From 1908, this view captures the scenic attractions of the Wissahickon Creek at Flourtown. A group of people on the banks of the creeks observes a young couple in a canoe. Since the late 1600s, the historic Wissahickon Creek has been an important waterway in Montgomery County for both industry, such as the erection of mills, and leisure, as seen here. A large portion of the Wissahickon has been preserved through various state and county parks.

One

Rockledge and
Huntingdon Valley

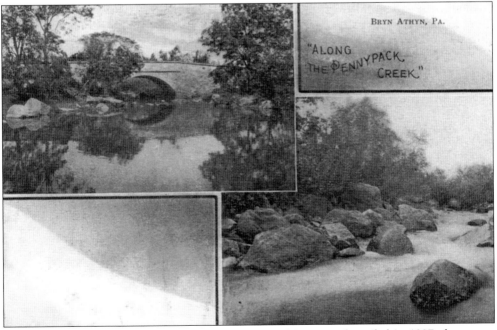

ALONG THE PENNYPACK CREEK, BRYN ATHYN. This postcard, mailed in 1907, shows two views of the Pennypack Creek at Bryn Athyn. The top view is of an old stone arch bridge over the creek. The lower view shows the Pennypack with large rocks along its banks.

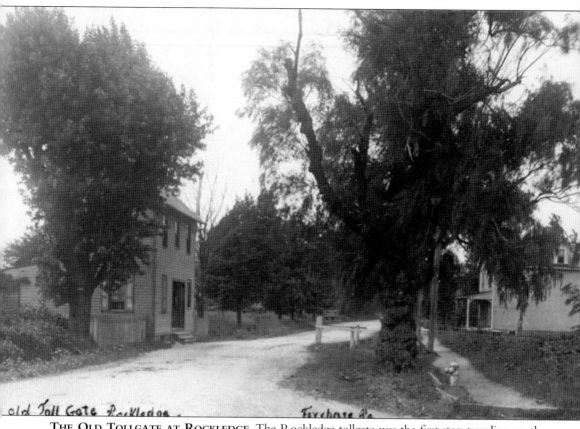

old Toll Gate Rockledge. Foxchase Rd

THE OLD TOLLGATE AT ROCKLEDGE. The Rockledge tollgate was the first stop traveling north on the Fox Chase–Huntingdon Turnpike in Montgomery County. This Sliker image from 1907 beautifully depicts the old tollgate and the "turnpike" with its dirt surface. The tollgate is shown to the left. On the opposite side of the road stood a small wooden fence with a post. When the tollgate's cross arm was in the down position, it would rest on the post, thereby blocking the roadway. In this view, the cross arm is in the up position and is faintly visible at the far end of the tollgate. Most, if not all, toll roads and turnpikes were eliminated in Montgomery County by the 1920s.

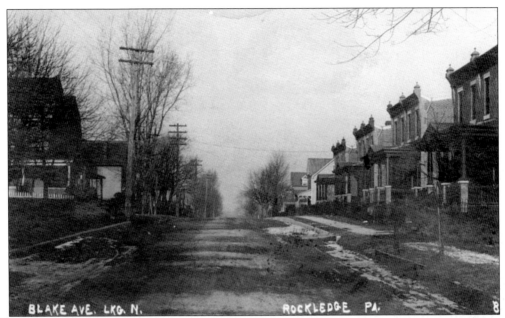

BLAKE AVENUE, ROCKLEDGE. This 1910 Sliker postcard view shows Blake Avenue, looking north from Huntingdon Pike in the borough of Rockledge. Newly constructed twin homes line the east side of the street. They still stand today, along with most of the other homes in this view.

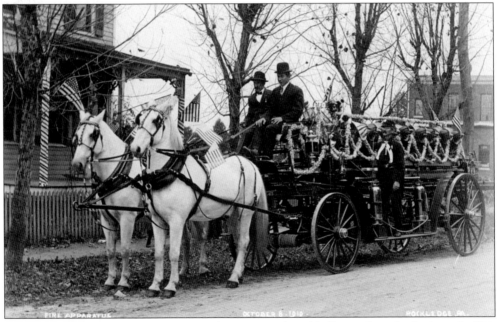

FIRE APPARATUS, ROCKLEDGE. Just as there are parades with fire trucks today, in the early 20th century, local fire companies often dressed up their equipment for various town celebrations. This wonderfully posed scene, dated October 8, 1910, shows Rockledge's fire company's apparatus, decorated with flags and garlands, being led by a pair of white horses. This William Sliker postcard records the look of early fire equipment and also captures a proud moment for two young men and for the older firemen on the fire truck.

11

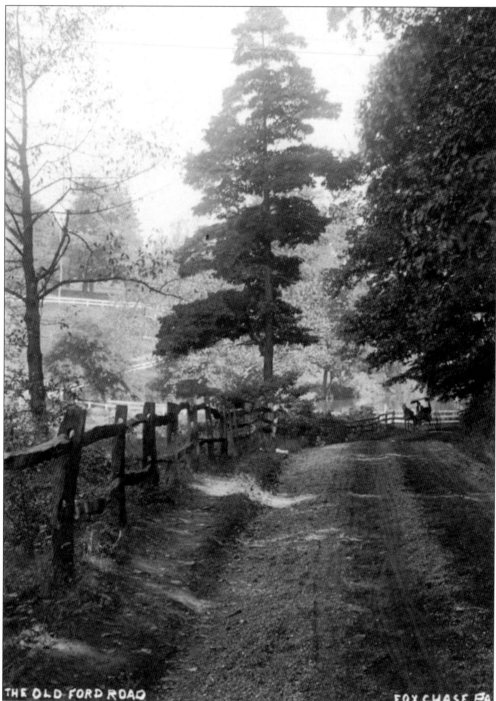

THE OLD FORD ROAD FOX CHASE PA

OLD FORD ROAD, FOX CHASE. This 1910 Sliker postcard shows Old Ford Road near Fox Chase. Old Ford Road is actually located in Abington Township west of Fox Chase and runs between Rockledge Borough and Walnut Hill. This view shows the beautiful scenery along the road, which featured trees, farms, and rolling hills. Riding along Old Ford Road today, one can still see some of this unspoiled landscape.

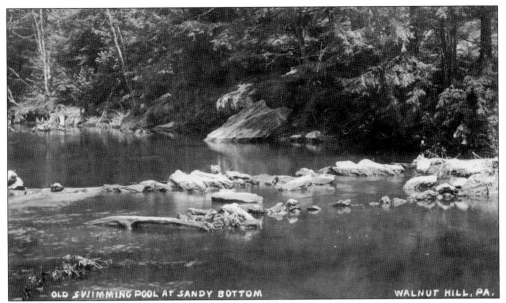

THE OLD SWIMMING POOL AT SANDY BOTTOM, WALNUT HILL. Driving along Moredon Road in Abington Township, the only hint of the area known as Walnut Hill is a large Septa sign for Walnut Hill Station, a small stop on the Newtown Branch of the Reading Railroad that has long been abandoned. Here the railroad tracks crossing Moredon Road have been paved over. The Pennypack Creek winds its way through Walnut Hill, as shown in this 1910 Sliker postcard view. This scene shows an area along the Pennypack known as Sandy Bottom that at one point contained a popular swimming hole. This area can still be seen in Lorimer County Park at Moredon Road.

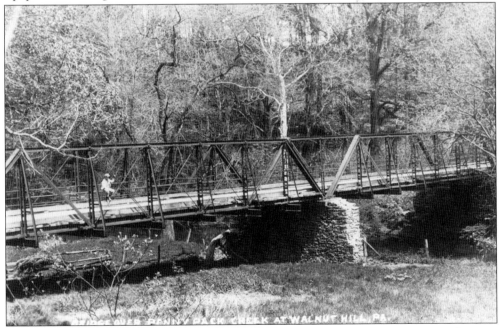

A BRIDGE OVER THE PENNYPACK CREEK, WALNUT HILL. This Sliker postcard view shows an early steel bridge on stone supports carrying Moredon Road over the Pennypack Creek at Walnut Hill. This bridge was replaced in 1932 with a concrete span that still stands today.

13

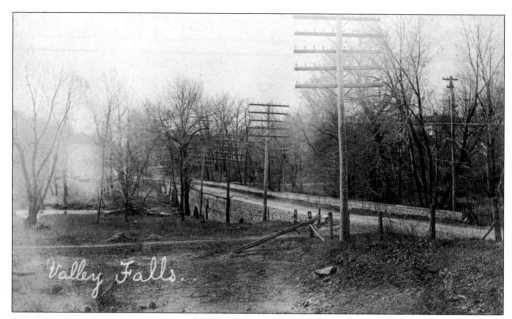

Valley Falls.

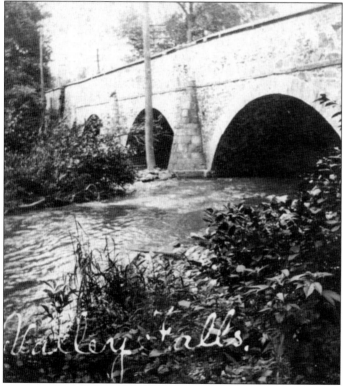

Valley Falls.

VALLEY FALLS. Valley Falls may not be a familiar locale to many. It is located along the Pennypack Creek where it crosses Huntingdon Pike, below Bethayres on the border of Abington and Lower Moreland Townships. A small falls located in a valley along the Pennypack gave the place its name. An interesting fact about Valley Falls is that at one time a small train station on the Fox Chase–Newtown Railroad was located here. The view above shows Valley Falls and the old Huntingdon Pike Bridge crossing the Pennypack Creek. The image to the left shows details of the bridge and creek at Valley Falls.

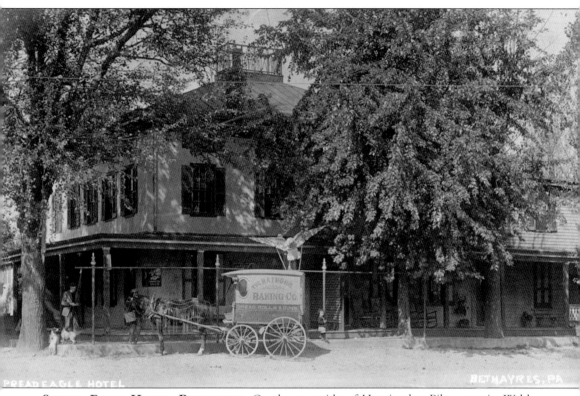

SPREAD EAGLE HOTEL, BETHAYRES. On the west side of Huntingdon Pike, opposite Welsh Road, stood the Spread Eagle Hotel, built in the late 1700s. A well-known landmark for over a century, the hotel was frequented by many who traveled along the old Fox Chase–Huntingdon Turnpike. This Sliker postcard view from 1907 shows a Hatboro Baking Company wagon parked in front of the hotel. The Spread Eagle was torn down in 1936.

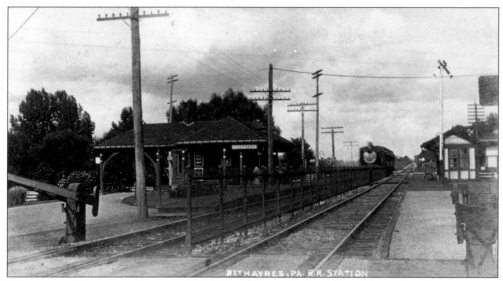

BETHAYRES RAILROAD STATION. The North Pennsylvania Railroad erected Bethayres Station at the junction of Welsh Road and Huntingdon Pike in the 1800s. The station was named after Elizabeth Ayres, the mother of one of the railroad's directors. Prior to 1936, the station and rail crossing were level with Huntingdon Pike, as shown in this 1908 Sliker postcard view. Here a train is about to arrive at the station; at the left, the signal cross arm is in the down position over Huntingdon Pike. After 1936, a bridge was erected to carry Huntingdon Pike over the railroad, and the crossing was eliminated.

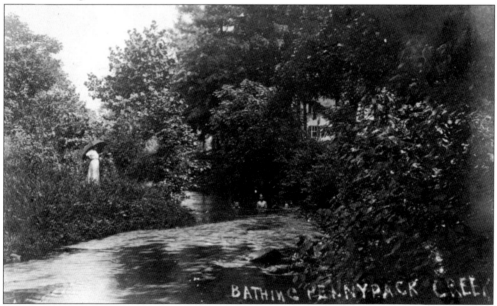

BATHING IN PENNYPACK CREEK, BETHAYRES. Prior to the popularity of swimming pools and water parks, local creeks such as the Pennypack served as oases for cooling off on a hot summer day. This 1906 view shows three young boys enjoying a swim in the Pennypack near Bethayres while a woman with a sun umbrella looks out over the creek. Residents of Montgomery County enjoyed the good clear waters of many streams for decades before water quality began to deteriorate in the mid-20th century.

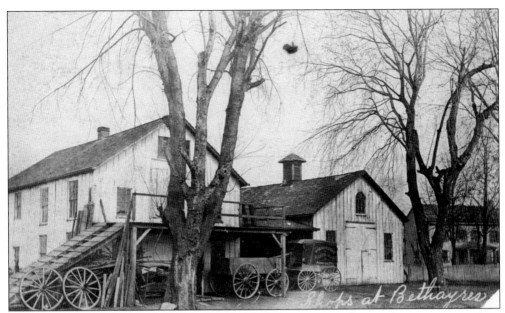

THE JOHN BARRETT SHOPS, BETHAYRES. The Huntingdon Valley/Bethayres area must have been quite an industrious place from the mid–1800s to the early 1900s, because there were two important carriage and blacksmith shops here. The view above shows Barrett's Carriage Shop facing Huntingdon Pike. Assorted carriages and wheels are visible, and closer inspection reveals that the wagon shown to the right belonged to McMahon Brothers General Store. This seems peculiar, because the McMahon family operated its own carriage shop on the other side of Welsh Road. The Barrett residence is shown to the right; it was located on the southwest corner of Welsh and Huntingdon Roads. In the Sliker postcard below, the carriage shop is shown with horses and wagons. None of these buildings stands today.

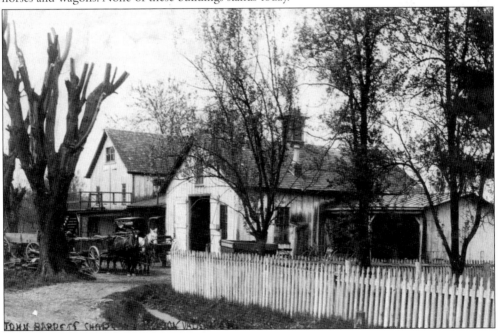

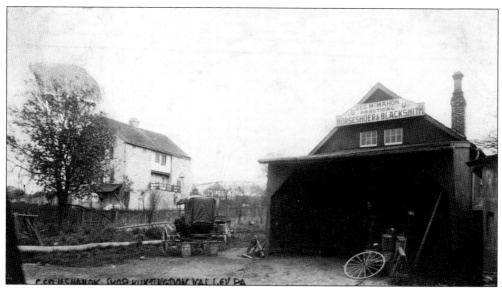

THE GEO. MCMAHON SHOP, HUNTINGDON VALLEY. The members of the McMahon family were very prominent residents in Huntingdon Valley from the 1800s to the mid-1900s. The sign above the shop reads, "Geo. McMahon practical Horsehoer & Blacksmith." The shop was once located on the north side of Welsh Road, west of Huntingdon Pike. Also seen in this 1907 Sliker postcard view is a large stone barn that was part of the McMahons' property. The McMahon family also owned the general store located next to this shop facing Huntingdon Pike. The shop closed in the 1940s and was later torn down.

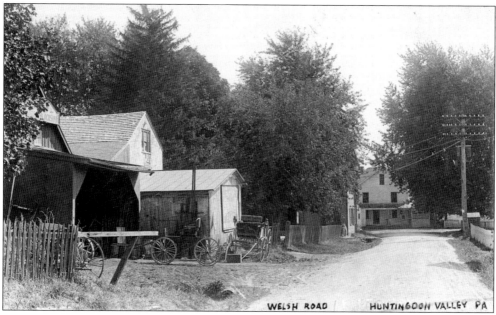

WELSH ROAD, HUNTINGDON VALLEY. This Sliker postcard view from 1908 looks east on Welsh Road toward Huntingdon Pike. The McMahon blacksmith shop is shown to the left with carriages parked on the property. The old Bethayres Tollgate is seen in the distance on Huntingdon Pike. This rare view offers a nice glimpse of the village of Huntingdon Valley 100 years ago. All buildings in this view are gone, and the entire streetscape has changed dramatically.

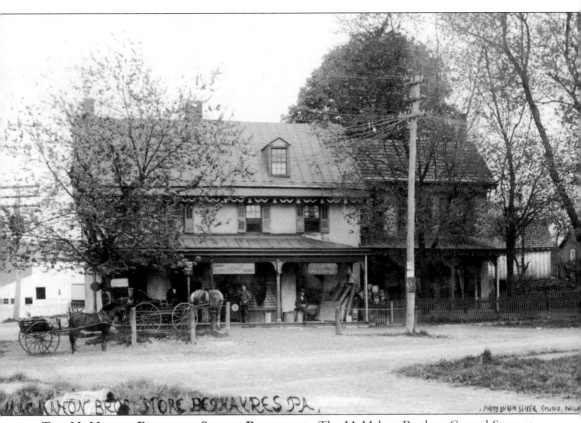

THE MCMAHON BROTHERS STORE, BETHAYRES. The McMahon Brothers General Store, at the northeast corner of Welsh Road and Huntingdon Pike, was a landmark for well over 100 years. From 1850 to 1960, the building also contained the Bethayres post office. Directly behind the store was George McMahon's blacksmith shop. This building was torn down in the late 1960s, when the intersection was widened. This postcard was produced by William Sliker.

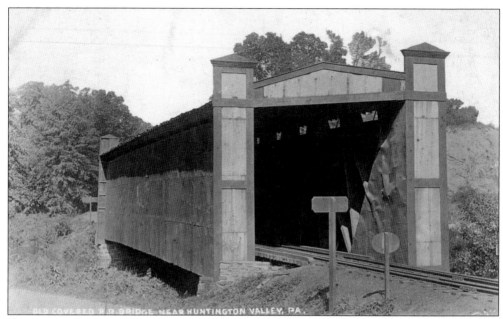

THE OLD COVERED RAILROAD BRIDGE NEAR HUNTINGDON VALLEY. A rather unusual fixture that stood in Huntingdon Valley for about 50 years was this old covered railroad bridge, located above Welsh Road near Terwood Road. Covered railroad bridges are quite rare, and one would speculate that the sparks and ashes that rose from early locomotives would have caused the covering to burn. Careful examination reveals that the bridge is constructed primarily of tin, with some wood paneling, and is set on stone supports. This bridge is no longer standing. This postcard was produced by William Sliker.

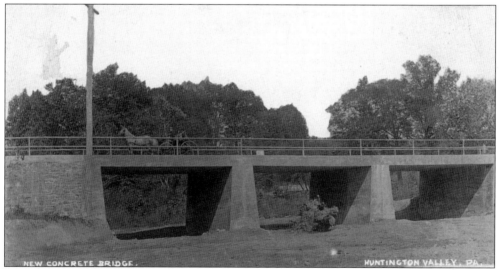

THE NEW CONCRETE BRIDGE, HUNTINGDON VALLEY. This *c.* 1910 Sliker postcard shows the newly built concrete bridge that carried Welsh Road over the Pennypack Creek. This structure, quite modern in appearance, replaced an old multi-arched stone bridge that was erected in the early 1800s. One fault the structure had was the sharp bend near the western end of the bridge near Terwood Road. That bend, along with increased automobile traffic, caused the bridge to outlive its usefulness, and it was replaced in the late 1960s.

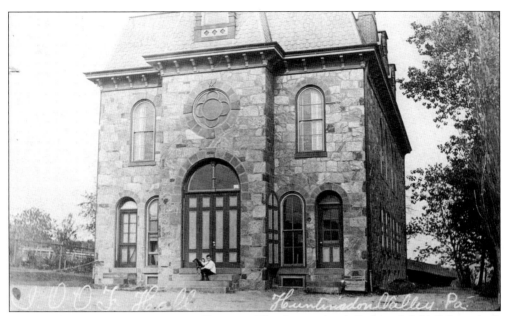

The IOOF Hall, Huntingdon Valley. The International Order of Odd Fellows built Eagle Hall as its meeting place on Huntingdon Pike north of Red Lion Road. Fancy cut stone, decorative arched windows, and a mansard roof accentuate the building's aesthetic charm. Built in 1850 and remodeled in 1869, the structure was torn down in 1955.

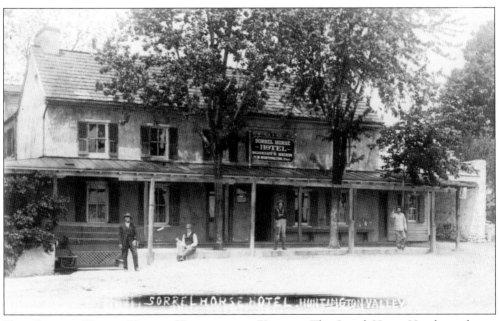

The Sorrel Horse Hotel, Huntingdon Valley. The Sorrel Horse Hotel stood near the intersection of Byberry Road and Huntingdon Pike, two important colonial roads. Byberry Road was laid out in the early 1700s to connect the Quaker settlement of Byberry to the Friends meetinghouse in Horsham. Huntingdon Pike was an old road that later became the Fox Chase-Huntingdon Turnpike. The Sorrel Horse dates back to 1750 and stood until it was torn down in 1936. At the time this Sliker postcard was made, H. W. Worthington was the hotel's proprietor.

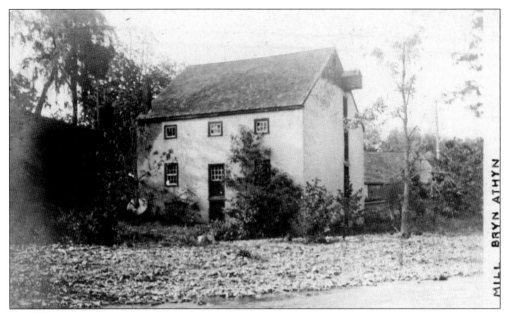

THE PENNYPACK MILL, BRYN ATHYN. This photo postcard from 1910 shows the side and rear of an old mill along the Pennypack Creek in Bryn Athyn. The mill dates from the 1830s, and its best-known owner was Casper Fetters, who operated the business in the 1860s and 1870s. Long known as Fetters Mill, the beautiful structure, reminiscent of the old milling days, still stands on a sharp bend on Fetters Mill Road along the picturesque Pennypack Creek.

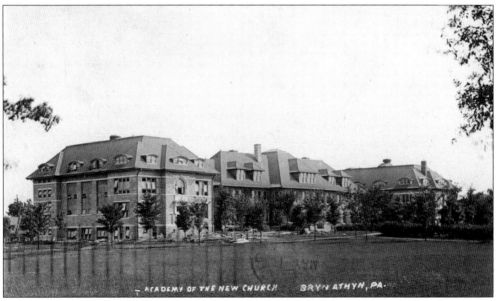

THE ACADEMY OF THE NEW CHURCH, BRYN ATHYN. Shown in this 1912 Sliker postcard view are three original buildings belonging to the Academy of the New Church. The library building is shown on the left. In the center is the main building, Benade Hall. The primary school, De Charms Hall, is to the right. William Henry Benade and Richard De Charms were early bishops in the New Church. The Academy of the New Church followed doctrines based on the writings of 18th-century Swedish philosopher Emmanuel Swedenborg.

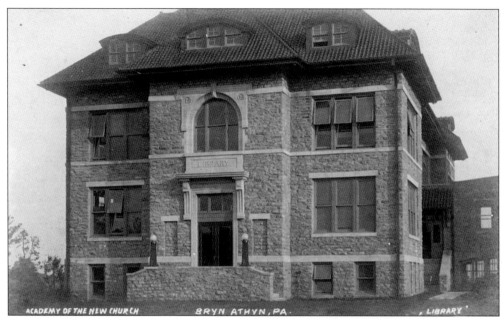

ACADEMY OF THE NEW CHURCH BRYN ATHYN, PA. , LIBRARY

THE LIBRARY AT THE ACADEMY OF THE NEW CHURCH, BRYN ATHYN. These two Sliker postcard views show the interior and exterior of the library at the Academy of the New Church. It was one of the original buildings opened in 1911. This building no longer functions as the school's library. The school's original property consisted of 19 acres at Huntingdon Pike and Buck Road.

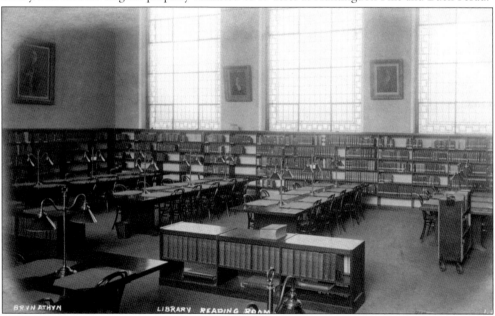

BRYN ATHYN LIBRARY READING ROOM

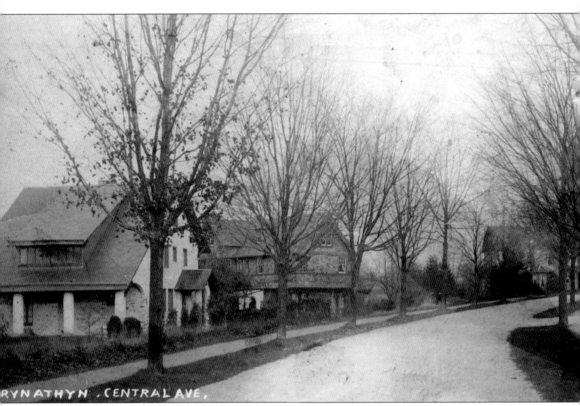

CENTRAL AVENUE, BRYN ATHYN. As part of the creation of the planned community of Bryn Athyn, John Pitcarin hired landscape designer Frederick Law Olmsted to lay out several streets that formed a loop. Originally, plans were made for North, Central, and South Avenues. North Avenue was never built, but Central Avenue, shown in this Sliker postcard view, contained many large and distinctive homes. Central Avenue is now known as Alnwick Road, and the homes shown here on the north side of the street still stand.

Two

CHELTENHAM, JENKINTOWN, AND ABINGTON

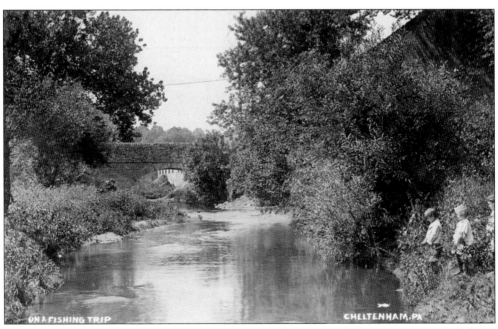

ON A FISHING TRIP, CHELTENHAM. This 1908 Sliker postcard shows three young children "on a fishing trip" along the banks of the Tacony (Tookany) Creek in Cheltenham. In the background is the old Central Avenue bridge and a portion of the old shovel and tool factory.

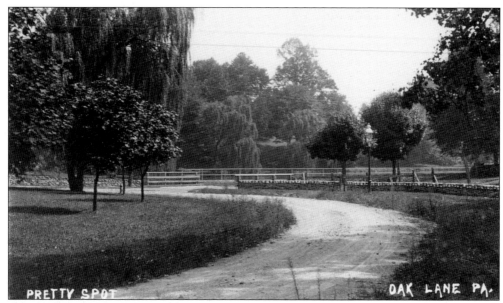

PRETTY SPOT, OAK LANE. This postcard view shows a winding dirt drive leading up to what is today's Cheltenham Avenue on the border of Philadelphia and Cheltenham. Over the bridge would have been Asbury Lake, part of the former Thomas Henry Asbury estate, which was created by damming the Little Tacony Creek. The lake, the creek, and the old Asbury estate are all gone and have been replaced by homes and business. Fortunately, photographer William Sliker preserved this "pretty spot" on this 1908 postcard.

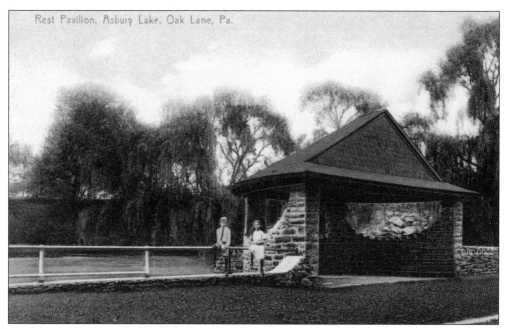

A REST PAVILION, ASBURY LAKE, OAK LANE. This quaint rest pavilion once stood along Cheltenham Avenue in Cheltenham Township alongside Asbury Lake on the Asbury estate grounds. This 1910 postcard by Philip Moore depicts the scenic lake and pavilion as a natural attraction to area children. Nothing remains of this scene today.

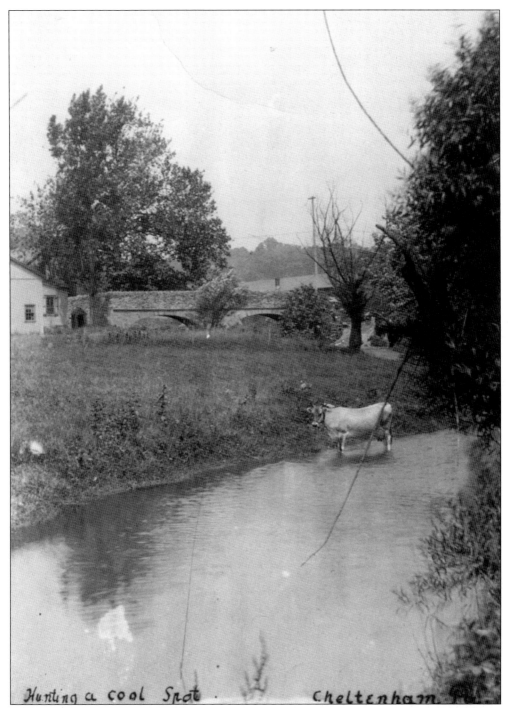

Hunting a cool Spot . Cheltenham.

HUNTING A COOL SPOT, CHELTENHAM. A lone cow wades in the cool waters of the Tacony (Tookany) Creek with the old Central Avenue bridge in the background. This Sliker postcard scene from 1909 illustrates the pastoral way of life that encompassed much of Montgomery County a century ago. Fortunately, some of the grounds along the Tacony Creek in this area have been preserved in Tookany Creek Park.

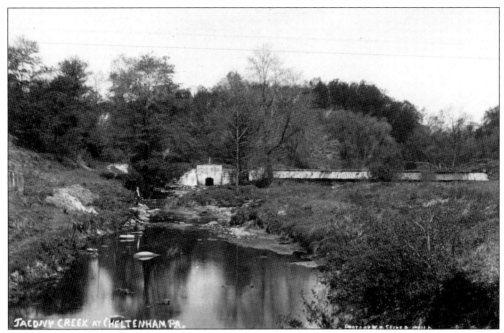

THE TACONY CREEK, CHELTENHAM. This Sliker postcard view from 1909 shows a beautiful Tacony (Tookany) Creek, looking north. In the distance can be seen an old milldam that helped power the Rowland Shovel Mill. From the late 1600s, the waters of this creek powered Cheltenham's earliest mills.

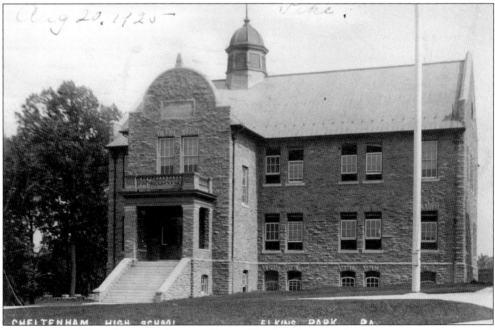

CHELTENHAM HIGH SCHOOL, ELKINS PARK. This building stood at Montgomery Avenue and High School Road in Elkins Park, Cheltenham Township, and was built in 1906, shortly after this Sliker postcard was made. This building remained the township high school until 1959. A 1994 fire destroyed the building.

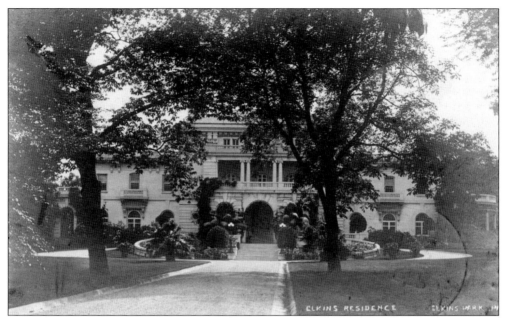

THE ELKINS RESIDENCE, ELKINS PARK. William L. Elkins built this mansion in the Italian Villa style between 1899 and 1902 on Ashbourne Road. Elkins, who made his vast fortune from trolley lines and traction companies, first settled in Cheltenham in the 1880s. Designed by Horace Trumbauer, the home was named Elstowe Park and remained in the Elkins family until the early 1930s. Still standing today, the home now serves as a religious retreat center. This postcard was produced by William Sliker.

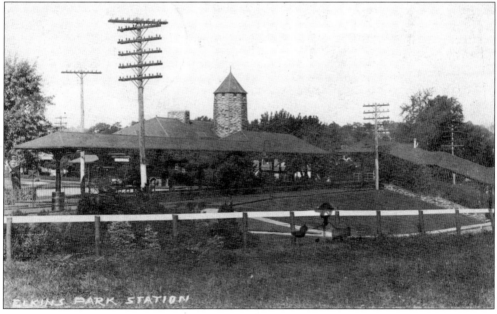

ELKINS PARK STATION. William Elkins's influence in Cheltenham Township was quite profound. The towns of Ogontz and Ashbourne adopted his name and became known as Elkins Park. In 1899, Elkins built the Elkins Park train station, which still operates today. This postcard was produced by William Sliker.

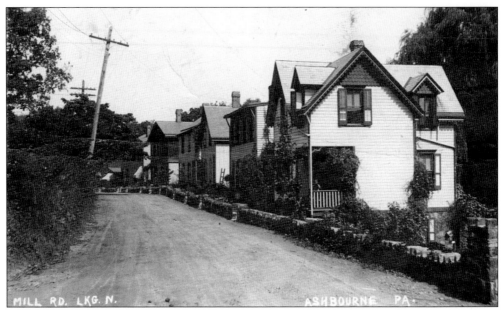

MILL ROAD, ASHBOURNE. This Sliker postcard view from 1910 shows Mill Road looking north between Ashbourne and Church Roads in Cheltenham Township. These small homes are still standing on the east side of the road below Tacony Creek. The homes may have housed mill workers who were employed in the many mills along the Tacony Creek. The mills in this area in the 1800s included the Tacony Edge Tool Works, a fork works, and a shovel works.

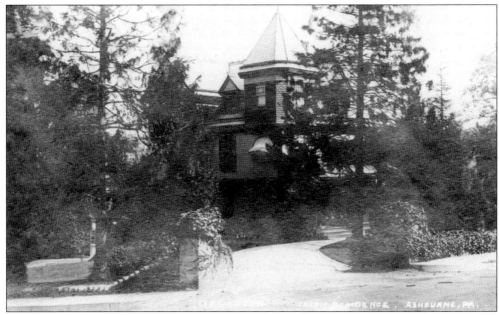

THE LANDIS RESIDENCE, ASHBOURNE. This beautiful Victorian home, with its many different rooflines, towers, and turrets, was built in the late 1800s by Samuel Landis. The small estate was known as Lygarton and was located on the northeast corner of Mill and Ashbourne Roads. The home is no longer standing. This postcard was produced by William Sliker.

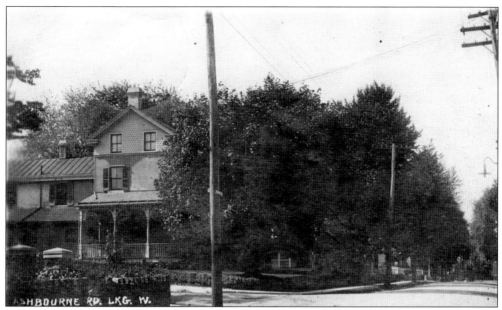

ASHBOURNE ROAD, ASHBOURNE. This 1910 Sliker postcard view shows Ashbourne Road looking west from Union Avenue in Ashbourne (now known as Elkins Park) in Cheltenham Township. This block between Union Avenue and Montgomery Avenue contains great examples of 19th-century architecture. The home on the left still stands, as does most of the block, which also includes an old stone church.

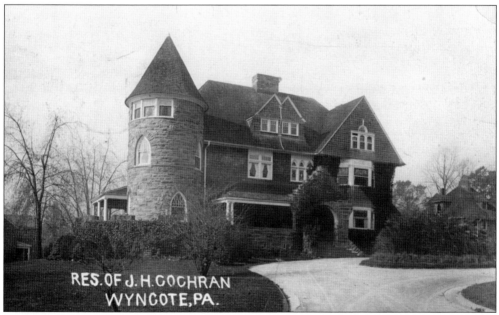

THE RESIDENCE OF J. H. COCHRAN, WYNCOTE. A drive along Bent Road in Wyncote in Cheltenham Township reveals an outstanding collection of homes and churches accentuated by a beautiful park. This surprisingly well preserved area contains many lavish homes designed by well-known architects. The Cochran home, shown in this 1910 view, still stands on Bent Road north of Church Road. W. W. Miller of North Wales photographed this image.

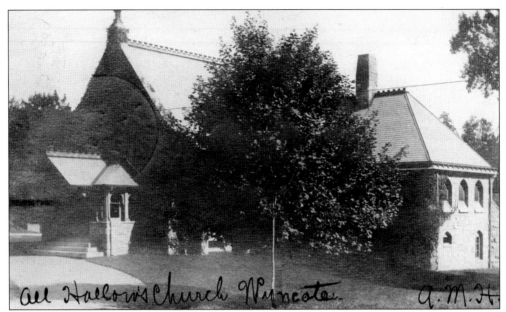

ALL HALLOW'S CHURCH, WYNCOTE. This real-photo postcard was mailed in 1907 and shows All Hallow's Episcopal Church in Wyncote. Located at the corner of Greenwood Avenue and Bent Road, the church was designed by well-known architect Frank Furness in 1896–1897. Wyncote developed as a community in Cheltenham Township in the latter half of the 1800s, and its post office was established in 1887.

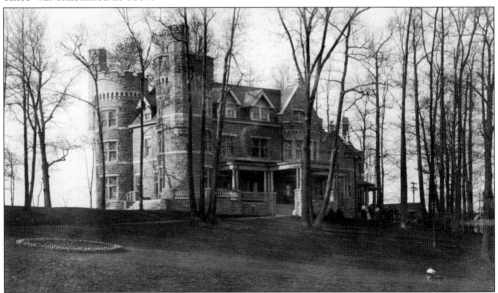

THE SCHOBLE RESIDENCE, WYNCOTE. Frank Schoble, a Philadelphia manufacturer of fur and felt hats, built this castlelike home, the Oaks, in the 1800s on a tract of land bounded by Church Road, Rices Mill Road, and Barker Road. In the 1800s and early 1900s, Cheltenham Township was a favorite area for building lavish and extravagant mansions for the new wealthy industrialists from Philadelphia. Schoble's mansion is an outstanding example of one of the lesser-known estates. The home, with modifications and additions, is still standing, and it is used as part of an assisted-living residence.

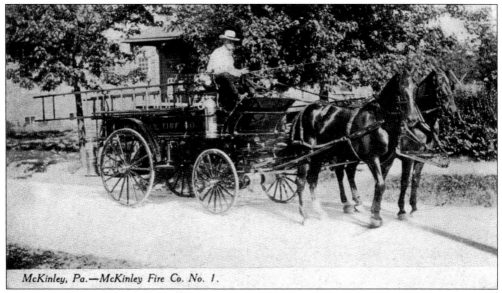

McKinley, Pa.—McKinley Fire Co. No. 1.

MCKINLEY FIRE COMPANY NO. 1. This rare World Postcard Company view from 1907 shows a horse-drawn fire wagon belonging to the McKinley Fire Company. The fire company was formed in 1906 in McKinley, located in Abington Township, in the area of Jenkintown Road above Township Line Road. McKinley was always a small community, and postcard views from this area are few. The town was named after assassinated U.S. president William McKinley, and it had its own post office from 1906 to 1923. The fire company is still serving the community today.

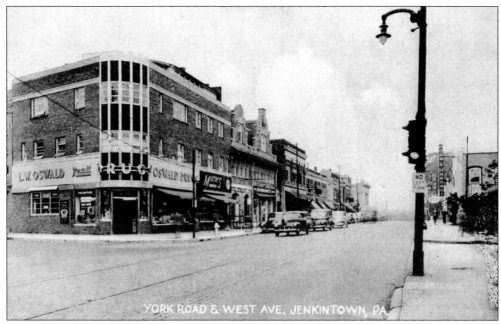

YORK ROAD & WEST AVE, JENKINTOWN, PA.

JENKINTOWN. This *c.* 1950 view shows the heart of downtown Jenkintown along York Road, looking north from West Avenue. Familiar landmarks such as Oswald Drugs still stand in Jenkintown. The noticeable difference between this view and the view today is the emptiness of the street. Today Jenkintown is a busy place, with many cars and pedestrians at this heavily traveled intersection.

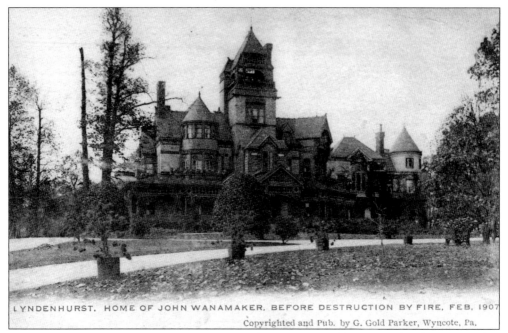

LYNDENHURST. HOME OF JOHN WANAMAKER, BEFORE DESTRUCTION BY FIRE, FEB, 1907

LINDENHURST, THE RESIDENCE OF JOHN WANAMAKER. The original John Wanamaker mansion, shown above, was built in 1883 and stood along Old York Road below Township Line Road in Cheltenham Township. The luxurious home was built for department store pioneer John Wanamaker. Tragically, this home, along with many priceless items, burned in 1907. The view below shows a rebuilt Wanamaker home that he resided in until his death in 1922; it is no longer standing. G. Gold Parker of Wyncote published the postcard above, and Philip H. Moore of Germantown produced the view below.

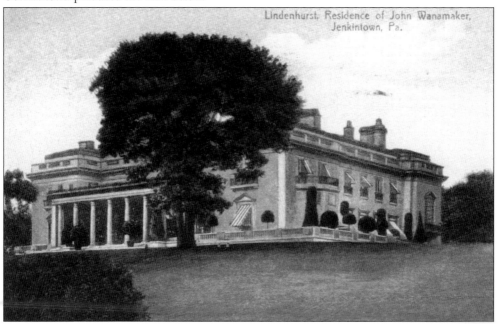

Lindenhurst, Residence of John Wanamaker, Jenkintown, Pa.

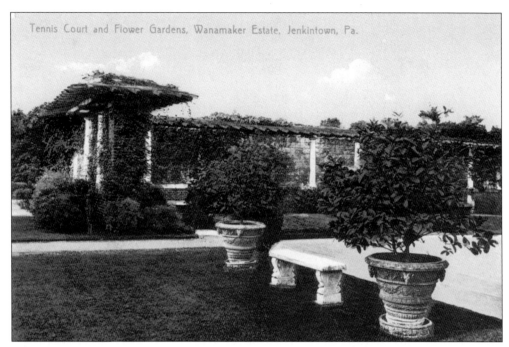

THE JOHN WANAMAKER RESIDENCE, NEAR JENKINTOWN. These postcard views illustrate the beautiful grounds that once existed at Lindenhurst, the residence of John Wanamaker in Cheltenham Township. Flower beds, garden walkways, and a portion of the tennis courts are shown in these views published by Philip Moore in 1908.

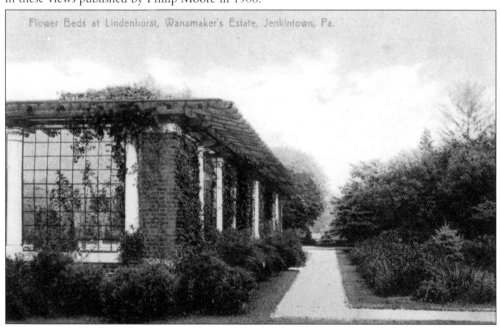

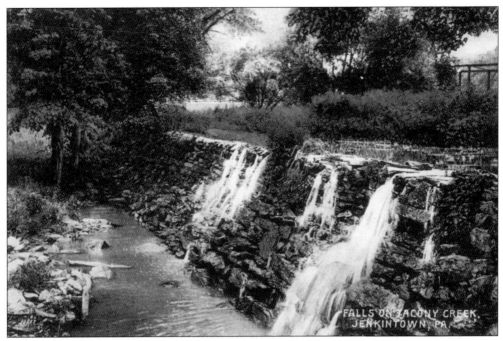

JENKINTOWN. Germantown photographer Philip Moore published these postcards of the country scenery around Jenkintown *c.* 1910. The view above shows a small waterfall on the Tacony Creek. The scene below shows a stone arch bridge spanning the Tacony Creek.

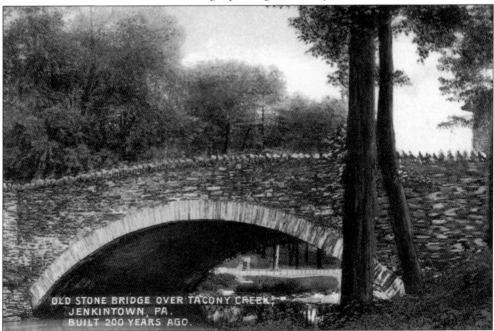

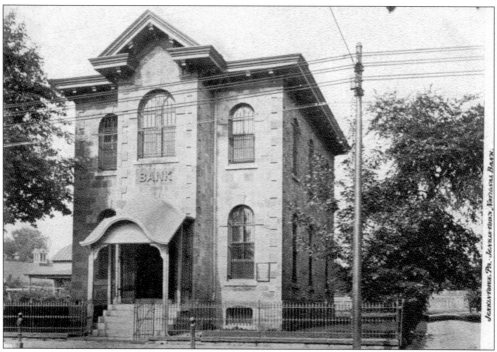

THE JENKINTOWN NATIONAL BANK, JENKINTOWN. The Jenkintown National Bank was founded in the latter part of the 1800s, and its first building was erected on the west side of Old York Road north of West Avenue, as shown in the World Postcard Company image above. This building was built in 1880 and was used until 1908. In 1908, the building shown in the Philip Moore postcard below was built, and it remained until 1925, when it was torn down. In 1925, a new bank building was erected on the northeast corner of Old York Road and West Avenue, and the Jenkintown National Bank combined with the Jenkintown Trust Company. These two images represent early bank architecture in Montgomery County and show the evolution of the business.

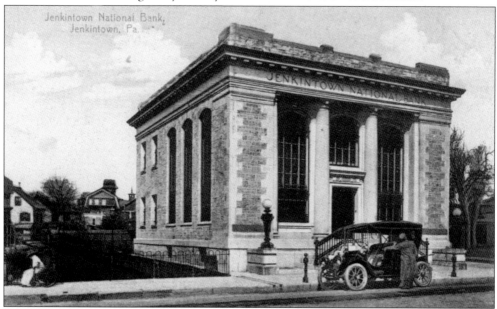

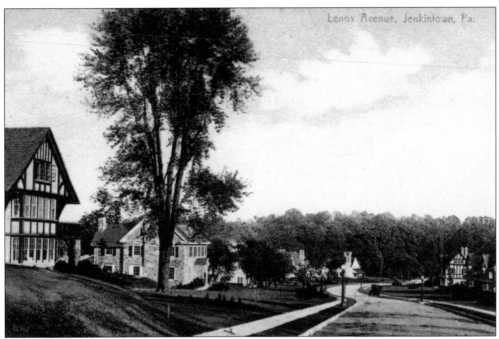

LENOX AVENUE, JENKINTOWN. This Philip Moore postcard shows Lenox Avenue looking east from Old York Road in 1908. This street is just outside the boundary of Jenkintown Borough and runs between Old York and Meetinghouse Roads in Abington Township. The homes shown here still stand and reflect a variety of architectural styles, from Tudor to Colonial Revival.

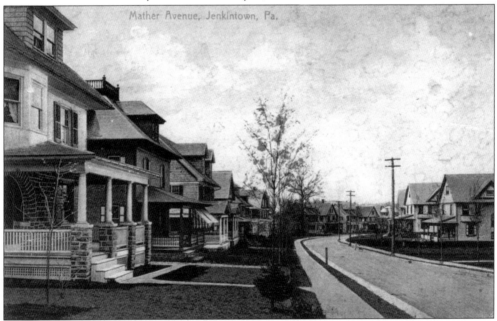

MATHER AVENUE, JENKINTOWN. Large, single homes dominate many of the streets of Jenkintown Borough, as is seen in this 1908 photograph of Mather Avenue taken by Philip Moore. This view looks south from the corner of Highland Avenue. All the homes still stand, though the trees have grown considerably on this block.

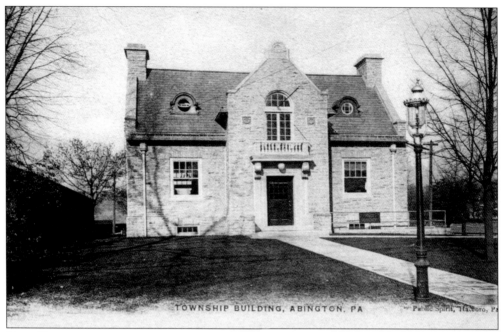

TOWNSHIP BUILDING, ABINGTON, PA — Public Spirit, Hatboro, Pa

THE TOWNSHIP BUILDING AND POLICE STATION, ABINGTON. As the population in the easternmost townships of Montgomery County grew, new facilities were needed for various governmental services. The Abington Township Administration Building is a prime example of an early municipal structure. Built in 1906, the building, which stood on the corner of Old York Road and Woodland Avenue, served Abington through 1926. It was demolished in the 1990s for the expansion of Abington Hospital. The Public Spirit of Hatboro produced the image above. The Miller studios of North Wales published the view below.

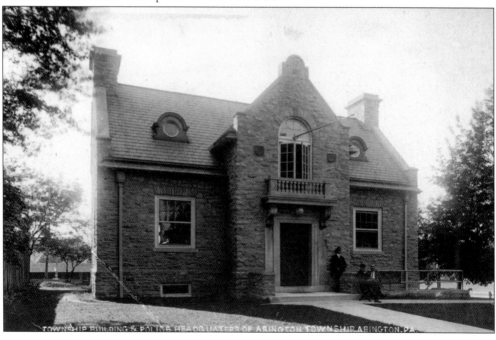

TOWNSHIP BUILDING & POLICE HEADQUATERS OF ABINGTON TOWNSHIP, ABINGTON, PA.

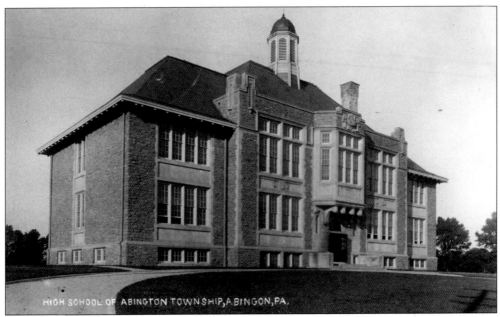

ABINGTON TOWNSHIP HIGH SCHOOL, ABINGTON. There were only a few public high schools in eastern Montgomery County 100 years ago, and they were spread out in places such as Cheltenham, Ambler, Norristown, Lansdale, Hatboro, and Lower Merion. This Miller postcard view from 1911 shows the high school in Abington. The original Abington School opened in 1888. This school opened in 1909 and remained the township high school until 1956; it was then known as Huntingdon Junior High until 1983. The school stood at Susquehanna and Huntingdon Roads and was torn down in 1996.

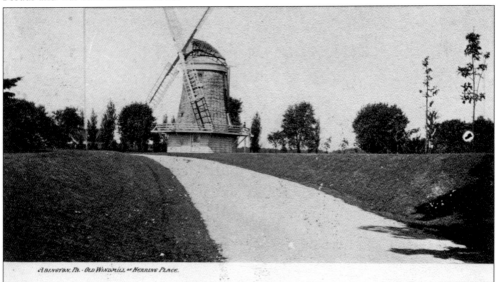

THE OLD WINDMILL ON HERRING PLACE, ABINGTON. A rather unusual landmark in Abington was this old Dutch-style windmill that stood along Huntingdon Road. The windmill was once part of a large estate known as Lyndanwalt, built in the early 1900s. Walter E. Herring, president of the Globe Ticket Company, owned the property. The windmill was torn down in 1985. This postcard was produced by the World Postcard Company.

Three

GLENSIDE, WILLOW GROVE, HATBORO, AND HORSHAM

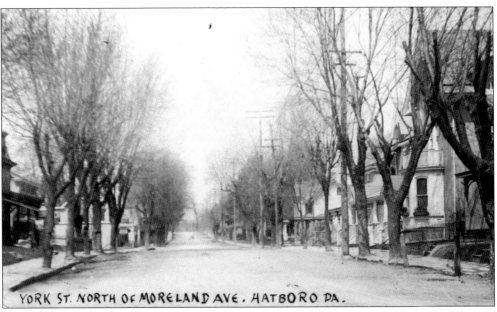

YORK ST. NORTH OF MORELAND AVE. HATBORO PA.

YORK ROAD, HATBORO. This Sliker postcard view shows York Road north of Moreland Avenue in downtown Hatboro. In this image, York Road, the main thoroughfare through town, is a dirt road. Various businesses and homes line the street.

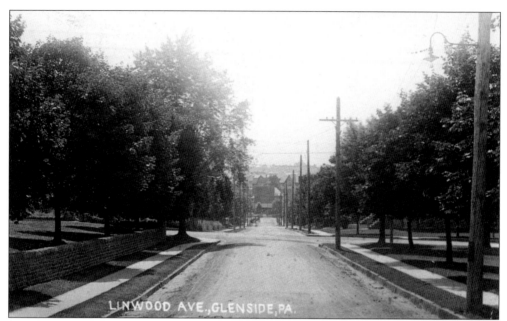

LINWOOD AVENUE, GLENSIDE. This Miller postcard view from 1909 shows a beautiful residential street scene in Glenside. Although the postcard states that this is Linwood Avenue (which is actually spelled Lynnwood), this appears to be a view of Fairhill Road, looking east from Easton Road. Fairhill Road turns into Lynnwood west of this point, and it may have been the same road in the early 1900s. Aside from beautiful residential streets, Glenside has a train station and a thriving business district along Easton Road.

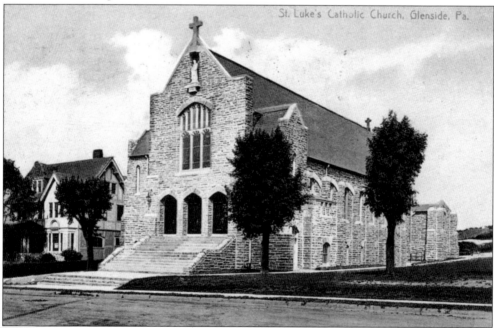

ST. LUKE'S CATHOLIC CHURCH, GLENSIDE. This 1910 Philip Moore postcard shows St. Luke's Catholic Church on Easton Road above Mount Carmel Avenue in Glenside. This beautiful stone building stood from 1906 to 1969, when a new church was built.

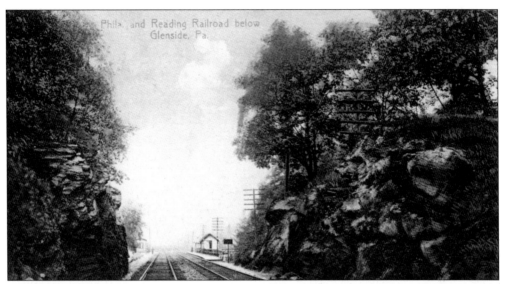

THE PHILADELPHIA AND READING RAILROAD, BELOW GLENSIDE. There has been a fascination with anything to do with railroads since the late 1800s. Various train stations and bridges were frequently pictured on early postcards. This Philip Moore postcard view from 1908 shows a nice glimpse of the tracks of the Philadelphia and Reading Railroad below Glenside. An unusual feature in this view is the large rocks that line both sides of the railway at this point, illustrating the flat path that was made for this rail line. When the original railroads were developed in the mid-1800s, clearing large rocks and hills was a major task.

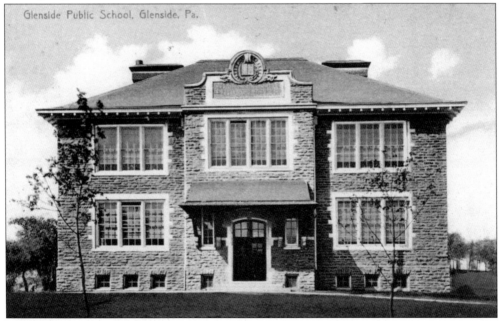

THE GLENSIDE PUBLIC SCHOOL, GLENSIDE. The Glenside area had two public schools. The Weldon School was used by Glenside students who resided in Abington Township, and the Glenside School served Cheltenham Township pupils. The Glenside School, shown on this 1909 Philip Moore postcard, was built in 1908 and was used as a school until the 1950s. This school was located on Easton Road at Springhouse Lane. It was demolished in the 1960s.

43

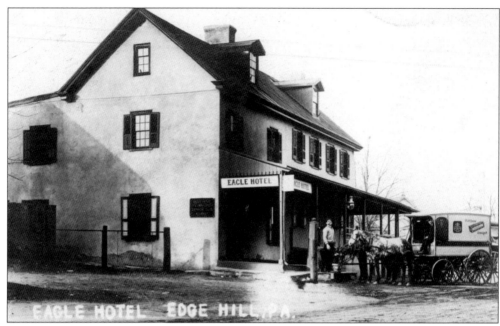

THE EAGLE HOTEL, EDGE HILL. The village of Edge Hill is located along Limekiln Pike in the area around Willow Grove Avenue and Mount Carmel Avenue in Cheltenham and Abington Townships. Probably the oldest building in Edge Hill is the Eagle Hotel, built in the early 1700s. In this Miller postcard 1910 view, a horse-drawn Nabisco wagon is parked in front of the hotel, probably making a delivery. This building, said to date from 1710, is now known as the Edge Hill Tavern.

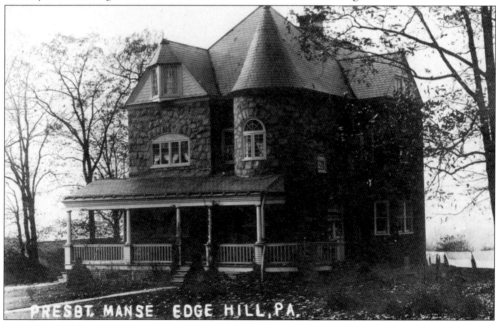

THE PRESBYTERIAN MANSE, EDGE HILL. A Presbyterian church was established in Edge Hill in 1876 on the corner of Edge Hill Road and Mount Carmel Avenue in Abington Township. The original church was replaced in 1925. The manse, shown in this 1910 view, still stands next to the church on Edge Hill Road. It dates back to *c.* 1900.

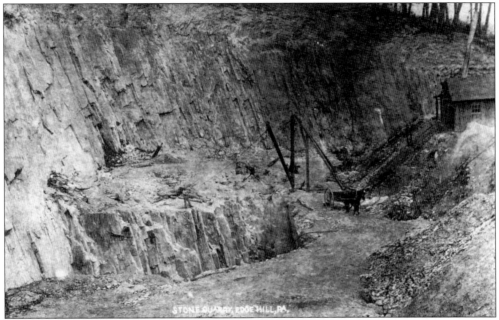

THE STONE QUARRY, EDGE HILL. The stone quarry in Edge Hill dates back to the 1880s. The quarry is still located on the west side of Willow Grove Avenue near Glenside Avenue. This 1912 view shows a horse-drawn cart and the rocky cliffs inside the quarry. This image illustrates an early industry that continues to operate in several locations in Montgomery County. (W. Miller postcard.)

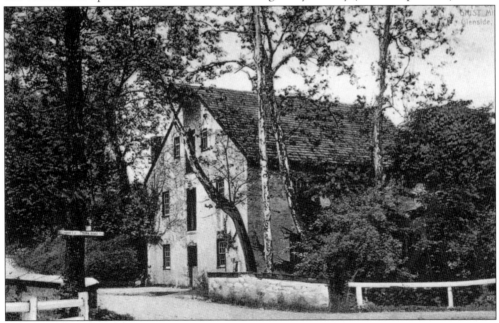

MORGAN'S MILL, WILLOW GROVE. Morgan's Mill was located at the corner of Davisville and Terwood Roads in Upper Moreland Township. The mill dates back to *c.* 1730. From 1730 to 1847, the mill passed through many hands. From 1847 to the 1950s, the mill was owned by Benjamin Morgan and his family. An early street sign on the left side of this 1910 view indicates that it is three miles to Betharyes to the east and that York Road is to the west. (Philip Moore postcard.)

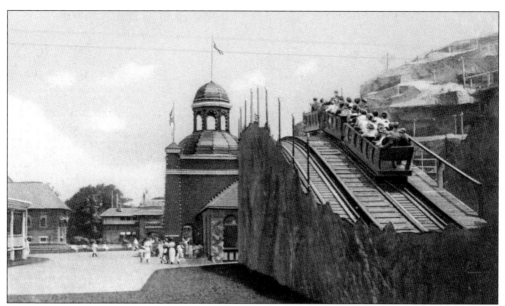

A JOYRIDE ON THE MOUNTAIN SCENIC RAILWAY, WILLOW GROVE PARK. This scene shows a railway car loaded with thrill-seekers on the famous Mountain Scenic Railway, one of the many attractions at Willow Grove Park in the early 1900s. This J. M. Canfield view states, "This is the only official souvenir postcard of Willow Grove Park." Canfield must have had exclusive rights to publish and sell views of the park at that time, *c.* 1907. Willow Grove Park was in operation from 1896 to 1976.

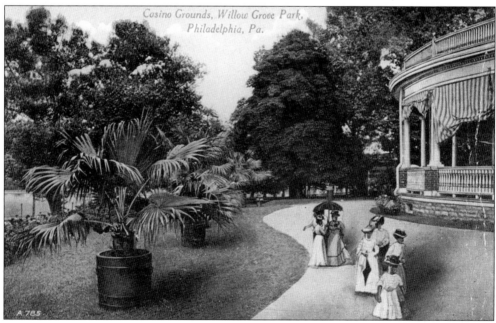

THE CASINO GROUNDS, WILLOW GROVE PARK. Well-dressed ladies stroll pass the casino at Willow Grove Park in this view from 1909. A portion of the casino is shown to the right, and the lake is to the left. The grounds at Willow Grove Park were always well maintained, with beautiful potted plants and trees.

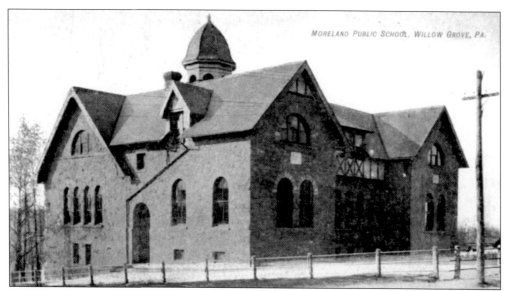

MORELAND PUBLIC SCHOOL, WILLOW GROVE. This rare postcard, published by the Public Spirit of Hatboro, shows the public school that was erected in Upper Moreland Township for the Willow Grove area. The school was built in 1895 and was designed by well-known architect Horace Trumbauer. The facility continued to serve as an institution of learning until the 1930s, when larger schools were built by the township. The building is still standing today on the north side of Davisville Road east of Old York Road, but it has changed dramatically in appearance.

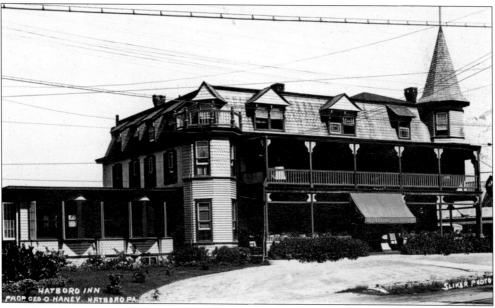

THE HATBORO INN, HATBORO. The Hatboro Inn was built in the late 1800s and replaced an earlier hotel that stood on the property on York Road. The inn was locally famous as the temporary home of Victor Herbert and his band members while they were performing at nearby Willow Grove Park. At the time this postcard was made *c.* 1912, the hotel was owned by George O. Haney and featured a large porch and second-floor balcony. The hotel was torn down in 1939. (Sliker postcard.)

47

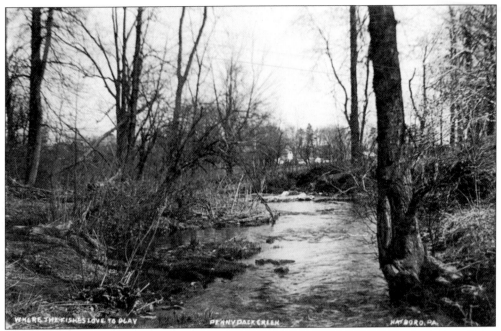

THE PENNYPACK CREEK, HATBORO. William Sliker photographed these two winter scenes along the Pennypack Creek in Hatboro *c.* 1907. Here the creek is no wider than a small brook, but its constantly flowing waters powered several mills in the area.

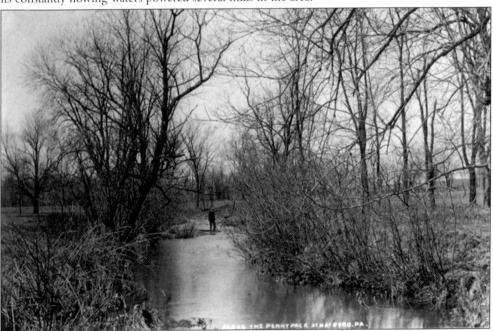

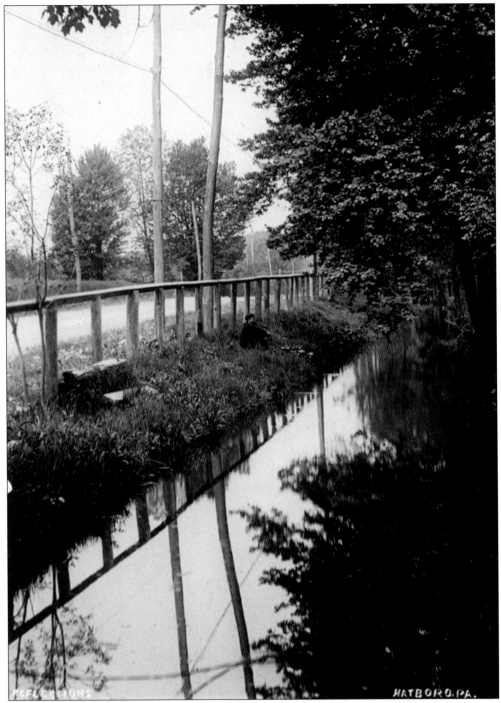

REFLECTIONS, HATBORO. A millrace from the Pennypack Creek along Horsham Road in Hatboro makes for a wonderful scene, photographed by William Sliker in 1907. A young boy rests along the banks of the race, and there are crystal-clear reflections in the water. This millrace fed the old Dungworth Mill at York and Horsham Roads, which still stands today. Nothing remains of the old millrace.

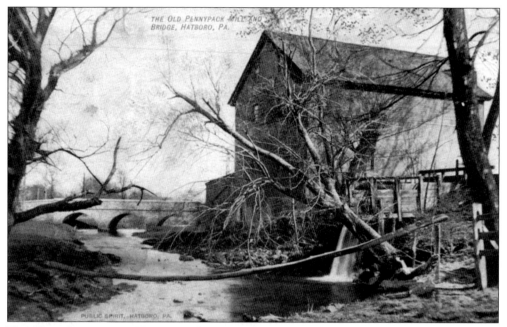

THE OLD PENNYPACK MILL AND BRIDGE, HATBORO. This 1907 view looks east along the Pennypack Creek and shows the rear of the 1724 Dungworth Mill. In the distance is the three-arch stone York Road bridge over the Pennypack, which was built in the 1820s. The mill is now a restaurant, and the bridge has been replaced by a concrete span. (Public Spirit postcard.)

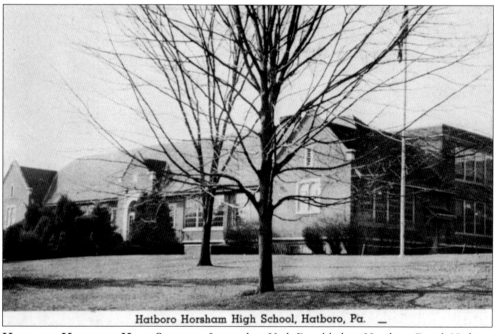

Hatboro Horsham High School, Hatboro, Pa.

HATBORO HORSHAM HIGH SCHOOL. Located on York Road below Horsham Road, Hatboro Horsham High School was built in the 1920s. Many additions have been made to the school throughout the years. This is a view of the school in the early 1950s. This building no longer functions as a school. (Art-Glo Postcard Company postcard.)

50

THE FRIENDS CEMETERY, HORSHAM MEETING, HORSHAM. Modest white tombstones mark the graves of buried Quakers at the Horsham Friends Meeting on Easton Road opposite the meetinghouse. This 1910 view shows a very large tree dominating the graveyard. This was the well-known old sassafras tree. It was said to predate the cemetery, which was founded in 1719. The tree was well documented and was listed as "a great tree" in a 1932 guide to historic trees in southeastern Pennsylvania. Unfortunately, it was destroyed by lightning in the early 1940s.

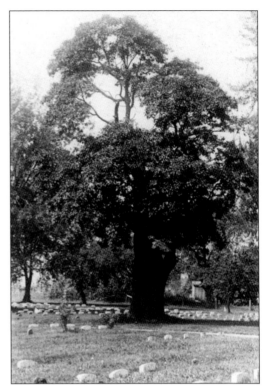

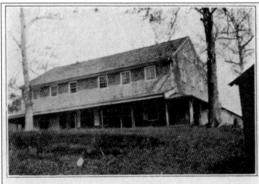

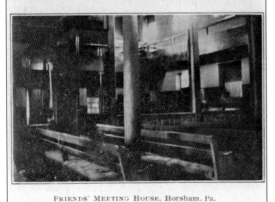

FRIENDS' MEETING HOUSE, Horsham, Pa.

THE FRIENDS MEETING HOUSE, HORSHAM. The Friends Book Association, located at 15th and Race in Philadelphia, published postcard views of all the Quaker meetings in the conference area of Pennsylvania, New Jersey, and Maryland. This interesting split-view card shows the interior and exterior of the Horsham Meeting House in 1915. It is free of adornment; the Quakers believed in simplicity and never decorated or embellished their places of worship. The exterior view shows a rectangular building, dating back to 1803, constructed of native fieldstone, while the interior view reveals a plain sanctuary of benches and columns.

51

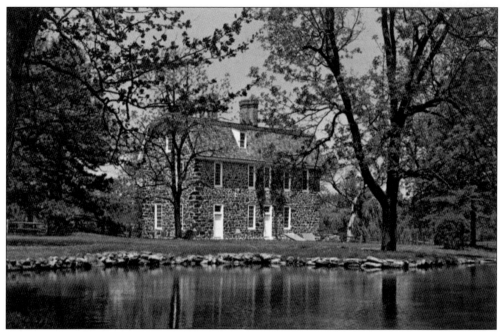

HORSHAM. These two views of Horsham were published in the early 1970s. They show the Keith House and Horsham Park, both located along Horsham Road. The Keith House, referred to as Graeme Park, was built in 1722 by Sir William Keith, colonial governor of Pennsylvania. Later that century, Dr. Thomas Graeme purchased the property. Today the home is opened to the public and is administered by the Pennsylvania Museum and Historic Commission. Visitors can also see the assortment of ducks and geese at the pond at Horsham Park, as seen in the view below.

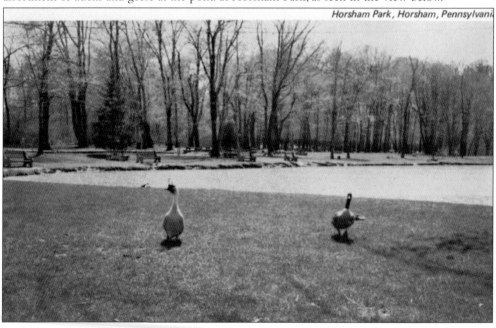

Horsham Park, Horsham, Pennsylvani

Four

FLOURTOWN, FORT WASHINGTON, AND AMBLER

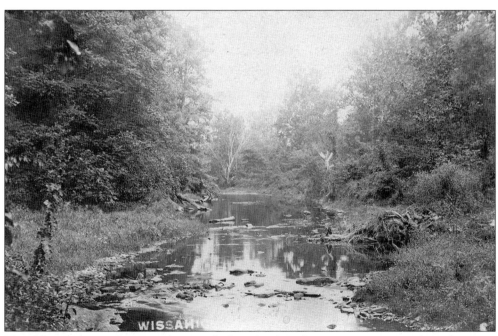

THE WISSAHICKON CREEK. The Wissahickon Creek is the primary waterway through eastern Montgomery County, emptying into the Schuylkill River near Manayunk in Philadelphia. Postcard views of the picturesque creek reveal beautiful natural scenery. This is a view of the Wissahickon near Ambler. (Batholomew postcard.)

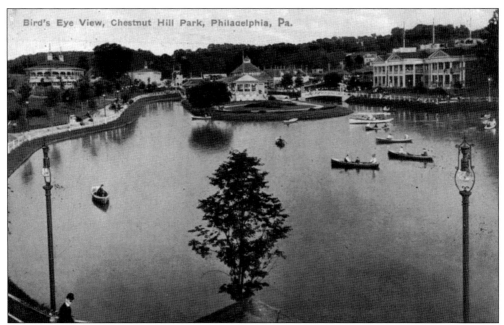

Bird's Eye View, Chestnut Hill Park, Philadelphia, Pa.

CHESTNUT HILL AMUSEMENT PARK. From 1898 to 1911, residents of eastern Montgomery County enjoyed the wonders of Chestnut Hill Amusement Park, located in Springfield Township off Bethlehem Pike. The short-lived park contained many attractions and amusements, including a carousel, a scenic mountain railway, and other rides. These two views from 1908 show the park in its heyday. Its beautiful spacious grounds contained a large lake that was used for pleasure boating. In the upper view to the right may be seen the park's Grand Casino, which was known as the dining and dance hall. The casino was designed by prominent architect Horace Trumbauer. The park was also known as White City Amusement Park.

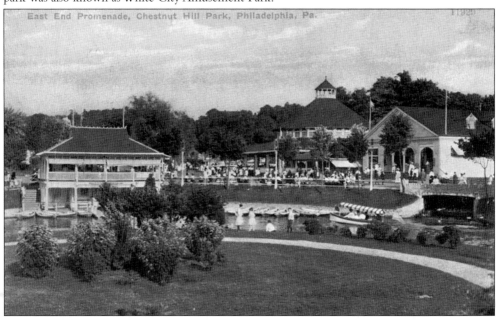

East End Promenade, Chestnut Hill Park, Philadelphia, Pa.

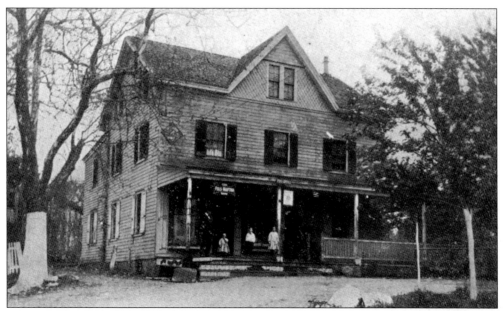

THE POST OFFICE, FLOURTOWN. Flourtown is an old village in Springfield Township. The village is named for the mills established along the Wissahickon Creek that ground grain into flour for area farmers in the 1700s and 1800s. Flourtown's post office was established in the early 1800s. This view shows the post office that stood on Bethlehem Pike at Springfield Avenue. The current post office is located in the Flourtown Shopping Center.

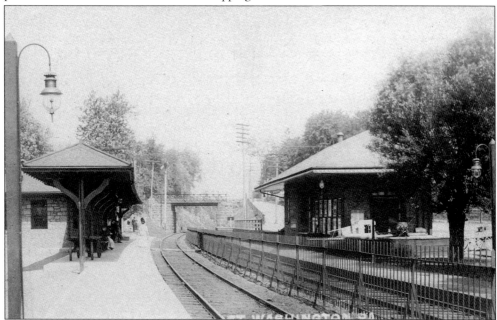

FORT WASHINGTON STATION. In the 1850s, the North Pennsylvania Railroad built a line from Philadelphia to northern Pennsylvania. Where this line crossed Bethlehem Pike, Fort Washington Station was erected. The station had a major impact on the village of Fort Washington and led to the building of the large Fort Washington House. This 1906 Bartholomew postcard shows the station looking toward Bethlehem Pike.

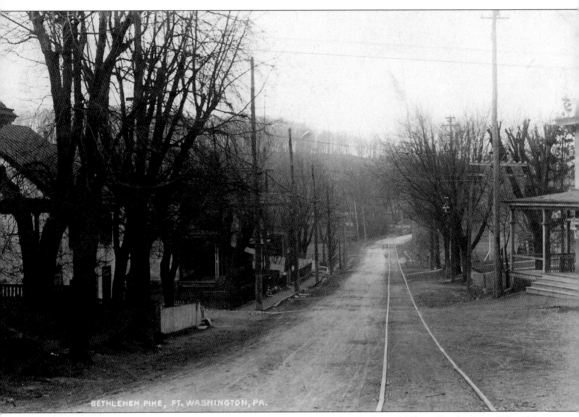

BETHLEHEM PIKE, FT. WASHINGTON, PA.

BETHLEHEM PIKE, FORT WASHINGTON. From a viewpoint in the middle of Bethlehem Pike, this scene looks south from the intersection with Lafayette Avenue in the village of Fort Washington. In this 1908 Miller postcard view, newly installed tracks of the Lehigh Valley Transit Company line the pike. Trolleys used this line beginning in 1902. Another notable feature shown is the long wooded ridge rising in the distance. This is part of a series of hills rising above Whitemarsh Valley that George Washington's army used as encampments during the Revolutionary War. Along this section of Bethlehem Pike is the Fort Hill section of Fort Washington State Park, seen here at the left. The buildings shown in this view still stand.

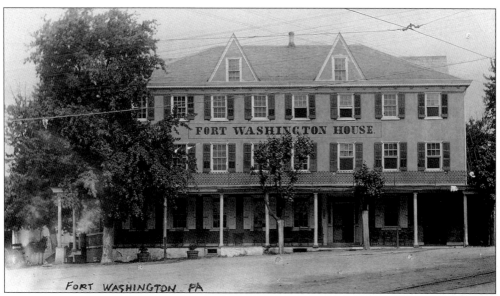

FORT WASHINGTON HOUSE, FORT WASHINGTON. Bethlehem Pike had been used as a main road for over a century when, in 1855, the North Pennsylvania Railroad built a line and a station in Fort Washington. This had a great impact on the village and helped Fort Washington to grow and prosper. To meet the demands of the now bustling village, the large three-and-a-half-story Fort Washington House was erected in 1855 as a hotel for travelers along the pike and the railroad. The building, seen in this 1910 Sliker postcard, still stands today.

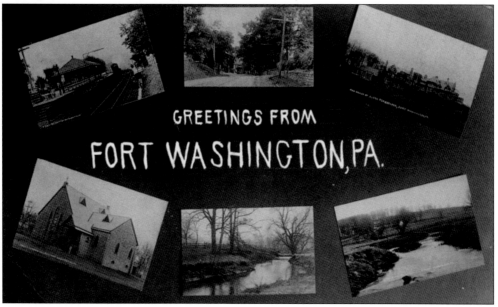

GREETINGS FROM FORT WASHINGTON. W. W. Miller from North Wales published many postcard views of Montgomery County. He produced several multi-view cards of different towns in the county, including this one of Fort Washington. On this postcard are six images that he photographed of Fort Washington. They are, clockwise starting at the upper left, Fort Washington Station, Bethlehem Pike, the Van Rensselear residence, Sandy Run near the Old Ladies Home, Sandy Run, and the Trinity Lutheran Church.

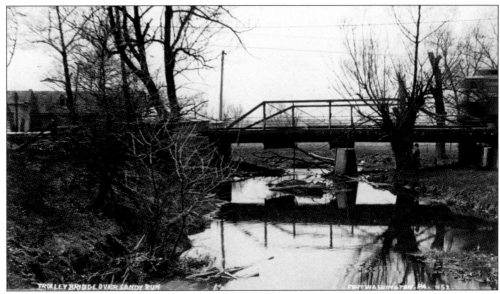

THE TROLLEY BRIDGE OVER SANDY RUN, FORT WASHINGTON. From 1902 to 1926, the Lehigh Valley Transit Company operated a trolley line on Bethlehem Pike from Chestnut Hill north to Spring House and up through North Wales and to points north. In several places, the newly electrified line required the building of separate bridges for the trolley. One such bridge carried the line over Sandy Run, a tributary to the Wissahickon Creek. In this Sliker postcard from 1908, a trolley is about to cross Sandy Run in Fort Washington. Nothing remains of this bridge today.

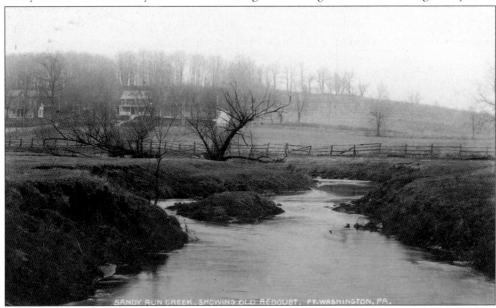

SANDY RUN, FORT WASHINGTON. The historical significance of our area is very evident in and around Fort Washington. This Miller postcard view depicts a portion of Sandy Run in the foreground and Fort Hill in the distance. Atop Fort Hill to the right were the remains of the old redoubt, or fort, used by Washington's army in the fall of 1777. Although nothing now remains of the original fort, the creation of Fort Washington State Park in 1953 preserves and commemorates this historic site.

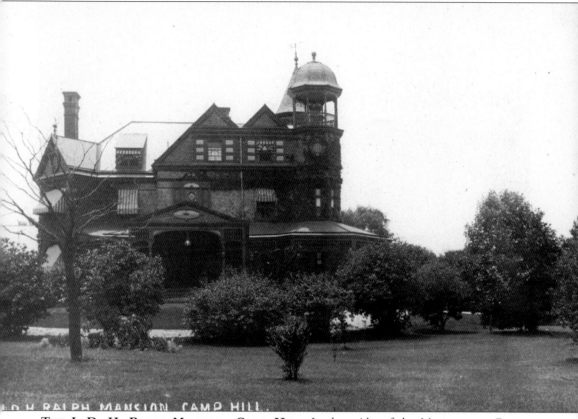

THE I. D. H. RALPH MANSION, CAMP HILL. In the midst of the Montgomery County countryside stood Arlington, the Irene Dupont Hendrickson Ralph mansion. Built in 1883 in the English Tudor and Queen Anne architectural style, it was radically different than most homes in the area. The asymmetrical home, with its wraparound porch, was highlighted by a four-story circular tower with a cupola at the top that must have afforded magnificent views of the surrounding area. Although his name may be misleading, Irene was a man. He was the former president of a railroad in Michigan and was cofounder of Stewart, Ralph & Company, snuff manufacturers. Arlington remained in the Ralph family until 1923. The home, along with its extensive grounds, was later sold and became the Edge Hill Golf Club. Currently the grounds are owned and maintained by the Sandy Hill Country Club, but the Ralph mansion that originally faced Valley Green Road near Camp Hill Road is gone. This postcard was produced by William Sliker.

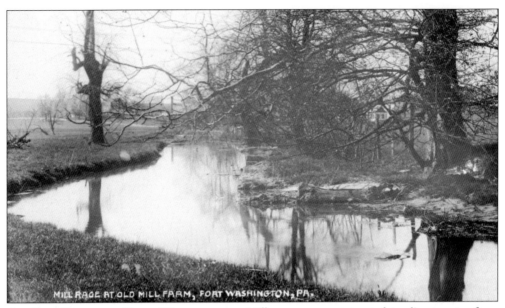

AN OLD MILLRACE, FORT WASHINGTON. Millraces were constructed to divert water from streams and channel it to provide power to the mills. The races could be compared to small canals in which water would flow to the mill, turning the waterwheel and powering the mill. This Miller postcard view from 1910 shows a portion of an old millrace near Sandy Run in the vicinity of Fort Washington.

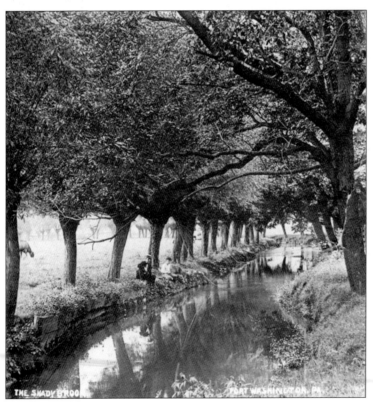

A SHADY BROOK, FORT WASHINGTON. Two young boys enjoy a shady spot along the banks of Sandy Run near Fort Washington. This Sliker postcard view from 1910 shows the scenic stream along Camp Hill Road near the border of Whitemarsh and Springfield Townships.

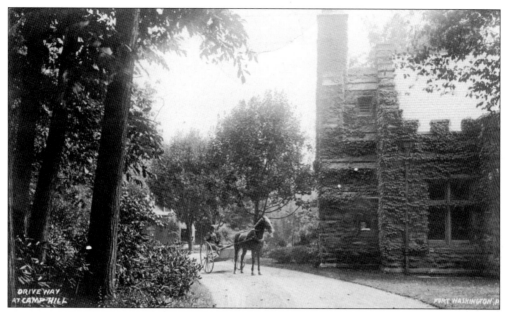

THE DRIVEWAY AT CAMP HILL, FORT WASHINGTON. This view shows a horse-drawn carriage on the driveway atop Camp Hill at Camp Hill Hall, the onetime residence of Alexander Van Rensselaer. Camp Hill Hall was built on the summit of Camp Hill off Pennsylvania Avenue. Sallie Van Rensselaer sent this Sliker postcard to M. Ruckman of Lahaska in 1913. Alexander and his wife, Sarah, had no children, so there is some mystery as to who Sallie was. Perhaps close friends knew Sarah as Sallie. This driveway, along with much of the Camp Hill estate, is still standing.

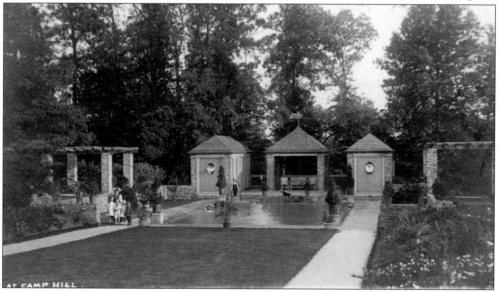

AT CAMP HILL. Camp Hill Hall had all the amenities of a lavish late-1800s estate. The grounds contained formal gardens, greenhouses, various paths, a gazebo, and, as shown in this view, an attractive swimming pool with cabanas. Closer examination of this William Sliker postcard shows a person in the pool, another on the steps, and a group of four children and an adult to the left. These people may be relatives of John Fell, Sarah Van Rensselaer's first husband, who died at a young age. Sarah was born into the well-known and wealthy Drexel family.

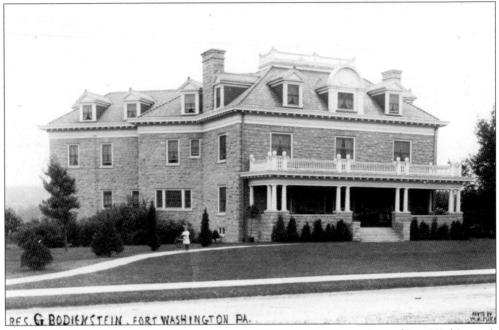

RES. G. BODIENSTEIN, FORT WASHINGTON PA.

THE RESIDENCE OF GEORGE BODENSTEIN, FORT WASHINGTON. One of Fort Washington's best-known residents from the early 1900s was chair manufacturer George Bodenstein, who built this beautiful mansion on Madison Avenue in 1903. The spacious house was home to Bodenstein, his wife, and their seven children. All three well-known Montgomery County postcard publishers, Miller, Sliker, and Bartholomew, produced views of this home. In the Sliker image above, the front façade of the home is shown; the person on the walkway might be one of Bodenstein's children. W. Miller's view below shows the other side of the house and reveals a beautiful porte-cochere, or covered arched entrance to the home.

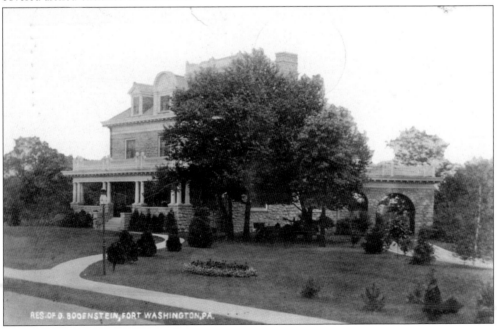

RES. OF G. BODENSTEIN, FORT WASHINGTON, PA.

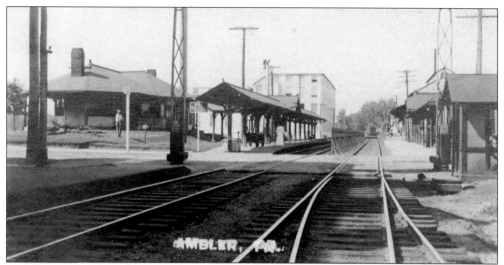

AMBLER STATION. This John Bartholomew postcard from 1905 shows the Ambler train station looking north toward Butler Avenue. The station dates back to the mid-1800s. It was built by the North Pennsylvania Railroad and was later operated by the Reading Company. The station was instrumental in Ambler's development into a vibrant business and industrial center. The station still stands today.

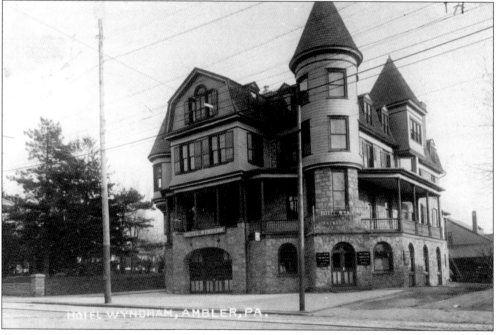

THE WYNDHAM HOTEL, AMBLER. The Victorian Wyndham Hotel, seen in this Miller postcard from 1910, has graced Ambler's Butler Avenue since 1893. Located a few blocks from the Ambler train station, the hotel has hosted many travelers who were passing through the town. The hotel contains many balconies that allow guests great views of Ambler's business district. The balconies were particularly useful during the many parades and celebrations held in town over the years. The Wyndham remains one of Ambler's best Victorian-style buildings. Currently the hotel is unoccupied and is awaiting a new life.

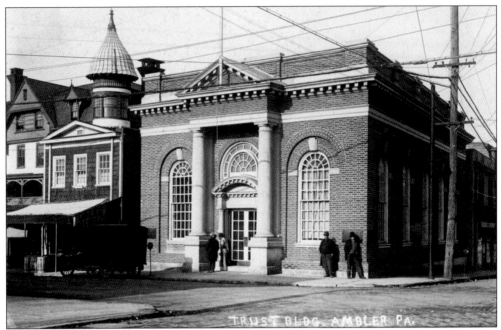

THE TRUST BUILDING, AMBLER. The Ambler Trust Company built this handsome Colonial Revival structure on the north side of Butler Avenue at the corner of Main Street in 1916. The large arched windows dominate the brick building, which is accented by decorative molding and classic pillars. The building still stands today in Ambler's Butler Avenue business district, which is currently undergoing a renaissance. This view is from 1924 and shows the turret from the demolished Hotel Ambler on the left.

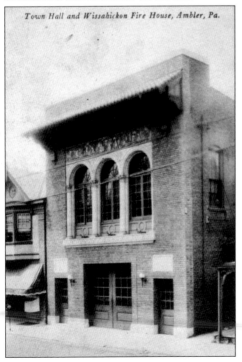

Town Hall and Wissahickon Fire House, Ambler, Pa.

TOWN HALL AND THE WISSAHICKON FIRE COMPANY, AMBLER. The Wissahickon Fire Company was founded in 1891 and was originally located on North Main Street. The firehouse shown here was built on Butler Avenue in 1917 and also served as borough hall. The fire company remained here until the new Race Street facility was opened in 1958.

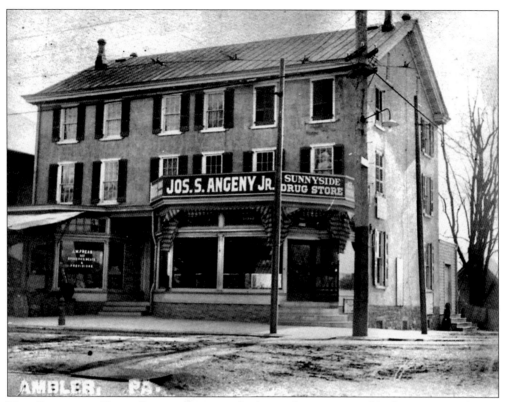

THE SUNNYSIDE DRUG STORE, AMBLER. At the southeast corner of Butler Avenue and Main Street in Ambler stood Joseph S. Angeny Jr.'s Sunnyside Drug Store. The large three-story building, which is still standing today, also contained the Freas meat store, shown to the left. Angeny is best known for the beautiful color postcards he published of his hometown of Ambler. Oddly, it was John Bartholomew of Lansdale who published this postcard of Angeny's store in 1908.

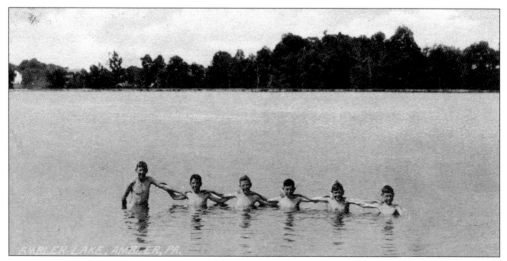

AMBLER LAKE, AMBLER. This postcard was published by Joseph Angeny, who operated a store on Butler Avenue in Ambler. It shows six boys enjoying the refreshing waters of Ambler Lake *c.* 1908. The view reflects an age of innocence when children enjoyed the great outdoors.

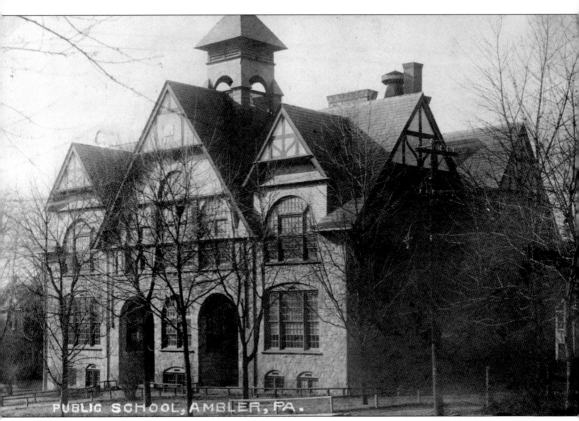

PUBLIC SCHOOL, AMBLER, PA.

FOREST AVENUE SCHOOL, AMBLER. The school building seen on this *c.* 1910 Miller postcard was called the Forest Avenue School and was located on Forest Avenue at Spring Garden Street in Ambler. This was Ambler's first school, built *c.* 1880. Numerous additions and alterations changed the school's appearance over the years. This school burned down in 1926 and was later rebuilt. A senior center occupies the school today.

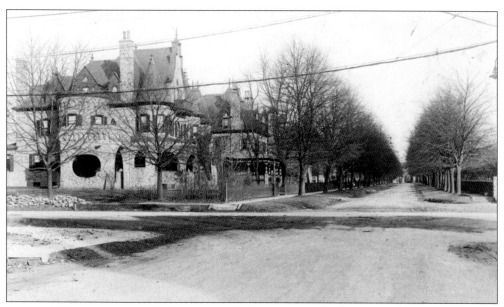

LINDENWOLD TERRACE, AMBLER. Richard Mattison, cofounder of Keasbey & Mattison's Century Asbestos Shingle Factory, built these large Victorian homes for the company's top executives. This 1910 view looks east on Lindenwold Terrace from the Bethlehem Pike intersection. These homes represent a truly unique collection of wealthy Victorian residences and reflect an era of industrial wealth.

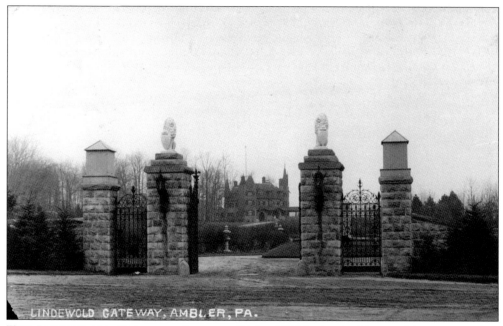

LINDEWOLD GATEWAY, AMBLER, PA.

THE LINDENWOLD GATEWAY, AMBLER. Richard V. Mattison's elaborate 24-room mansion, Lindenwold, is seen through beautiful open gates on this 1910 Miller postcard. Although the mansion has been extensively altered, these gates, with the lions atop the posts, still stand at the corner of Bethlehem Pike and Lindenwold Terrace in Ambler.

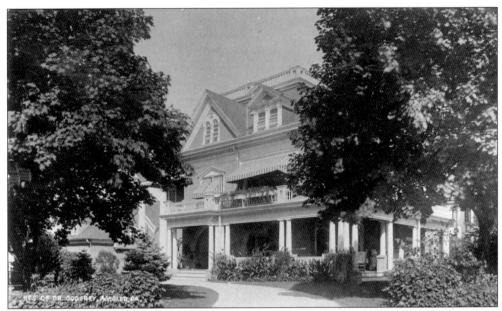

Dr. Godfrey's Residence, Ambler. An examination of Ambler today reveals beautiful large homes erected by the town's wealthier citizens more than a century ago. These extravagant homes were not limited to the large Keasbey-Mattison mansions built throughout Ambler. This Miller postcard view shows the beautiful Colonial Revival mansion of Dr. Godfrey, which features a large porch, a second-floor balcony, and a semicircular driveway. This home still stands on the northwest corner of Bethlehem Pike and Lindenwold Avenue.

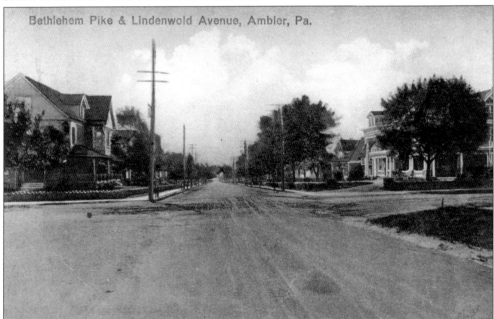

Bethlehem Pike & Lindenwold Avenue, Ambler, Pa.

Bethlehem Pike & Lindenwold Avenue, Ambler. This postcard was published *c.* 1908 by Rees C. Roberts, who operated a drugstore on the northeast corner of Main Street and Butler Avenue. This view looks west on Lindenwold Avenue at Bethlehem Pike. Large homes dominate this section of Ambler. Dr. Godfrey's house is shown to the right.

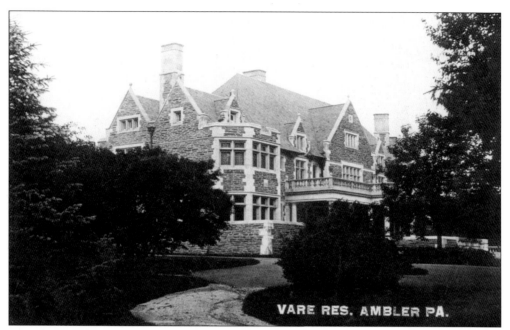

THE VARE RESIDENCE, AMBLER. Another fine estate in Montgomery County was Abendruh, located on a hill above the Wissahickon Creek in Whitemarsh Township near Ambler. Built in the 1890s in the old English or Jacobean style, the stone home was originally the residence of Charles Bergner of the Bergner and Engel Brewing Company. At the time this John Bartholomew postcard was made *c.* 1910, the Vare family owned the house. Only part of the main house, shown above, is still standing. The view below shows the driveway and entrance gates along Morris Road, which are still there today.

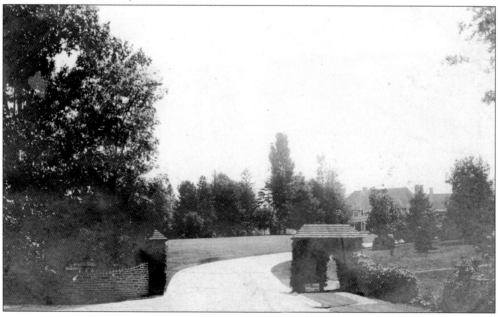

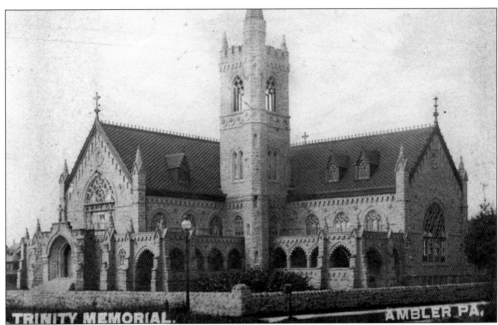

TRINITY MEMORIAL. AMBLER PA.

TRINITY MEMORIAL EPISCOPAL CHURCH, AMBLER. Ambler's wealthiest and most prolific resident, Richard Mattison, built Trinity Memorial Church in honor of his daughter, who died at the age of four. The beautiful church was built in the 1890s on Bethlehem Pike. The church contained beautiful stonework and elaborate arches and finials. It was topped by a four-story bell tower. Inside, rich wood paneling dominated the sanctuary, accented by breathtaking stained glass. Tragically, the beautiful Gothic Revival structure burned on June 16, 1986. A new stone church has been erected on the same site. The postcard above by John Bartholomew shows the church in 1905. The view below shows the church in the 1960s.

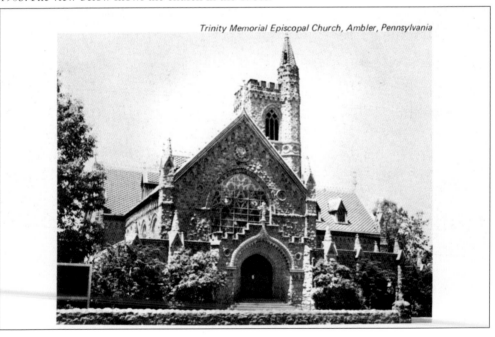

Trinity Memorial Episcopal Church, Ambler, Pennsylvania

Five

Lower Gwynedd and the North Wales Area

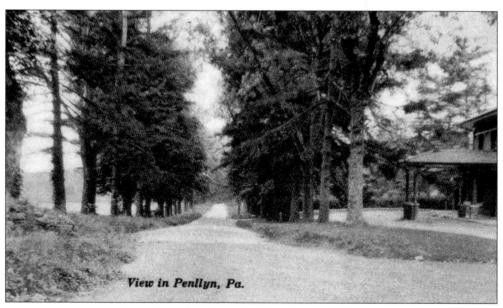

View in Penllyn, Pa.

VIEW IN PENLLYN. This *c.* 1920 view shows Pershing Avenue looking north from Penllyn Pike, with a portion of the Penllyn Station shown to the right. Pershing is an old family name in the Penllyn area. This street looks different today, as many of the large trees have been replaced by newer homes. Penllyn Pike no longer intersects this street here; it has been rerouted to the north end of Pershing Avenue.

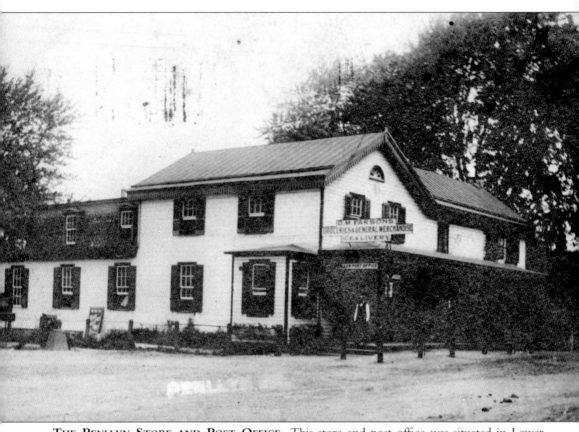

THE PENLLYN STORE AND POST OFFICE. This store and post office was situated in Lower Gwynedd Township, across the railroad from the Penllyn Station along Old Penllyn Pike. Penllyn's post office was established in 1858. Shown in this 1910 Bartholomew postcard (ironically postmarked from Ambler) is the post office and store. The business was operated at that time by O. M. Parsons, who advertised groceries and general merchandise. The Penllyn post office still exists, but it is now located in a modern facility on Bethlehem Pike. This building is still standing and contains a business.

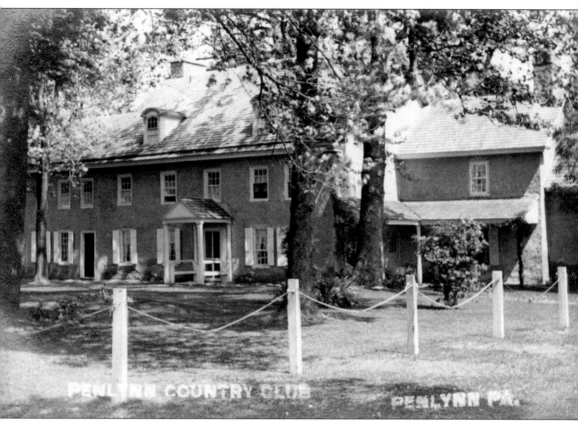

THE PENLLYN COUNTRY CLUB, PENLLYN. The Penllyn Country Club was founded in 1897 by a group of Penllyn residents to promote social gatherings of the wealthy people in the area. Originally the club had a small golf course, which lasted until 1902. For the next several decades, polo was the main activity. The Foulke family originally used the building shown on this Bartholomew postcard as their farm. The club still uses this house, which dates back to 1786. The club features tennis courts and a swimming pool.

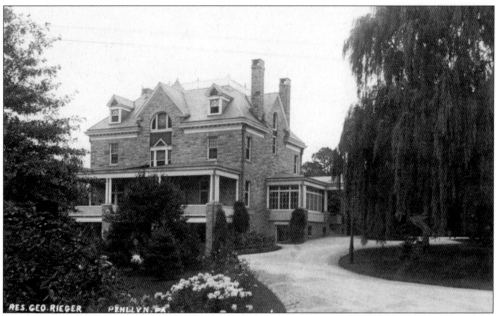

THE GEORGE RIEGER RESIDENCE, PENLLYN. The elaborate Rieger mansion and its extensive grounds in Penllyn were popular subjects for postcard publishers. The 1899 mansion was built for Bergdoll beer manufacturer George Rieger. The home is still located along Penllyn Pike near Spring House. The William Sliker image shown above provides a rare glimpse of the rear of the home. The John Bartholomew image below shows a bit of the rustic landscape. A craftsman-made wooden footbridge spans Willow Run on the property. In many ways, the Rieger mansion embodies all the elements of a wealthy entrepreneur's estate in Montgomery County: a splendid mansion surrounded by grounds embellished with beautiful landscaping.

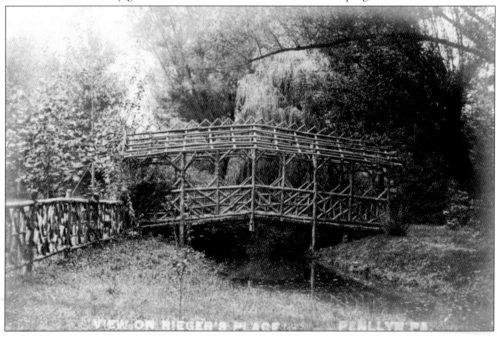

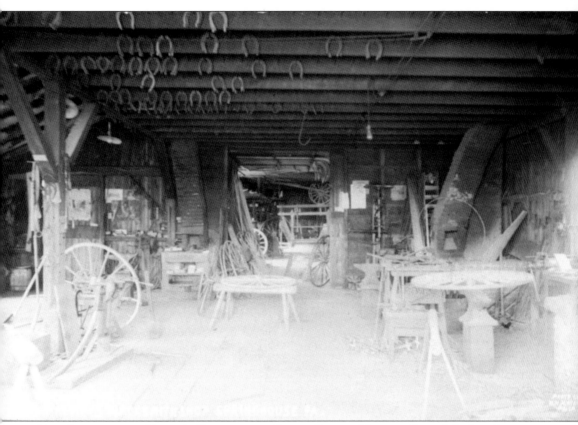

THE INTERIOR OF REMPP'S BLACKSMITH SHOP, SPRING HOUSE. One of the best-known blacksmith shops in Montgomery County was started by Jacob Rempp in 1876. With the death of Jacob in 1914, his son Julius took over the business, which was located on Bethlehem Pike south of Penllyn Pike across from the Spring House. Both Rempps had impeccable reputations as highly skilled blacksmiths, an important and respected trade in the 1800s and 1900s. Even as the blacksmith trade began to fade, Julius was called upon to make reproductions of colonial hardware for Washington's headquarters at Valley Forge as well as for numerous historic homes in Berks County. Julius operated the shop until 1964; he died in 1965. The shop remained intact until it was torn down in 1976. Much of the original blacksmith shop's contents were moved to a museum in Lancaster County. This Sliker postcard view shows the interior of the 1901 building, with assorted carriage wheels and abundant horseshoes hanging from the rafters.

HALLOWELL'S STORE, SPRING HOUSE. On the west side of Bethlehem Pike, just north of Sumneytown Pike, stood Hallowell's General Store. The store was opened by Isaac Hallowell in 1867 and served as a centerpiece for the village of Spring House. The building also contained the post office, which stayed with Hallowell and his son Walter until 1923. This William Sliker postcard from 1908 shows local residents on the steps of the store. The building is no longer standing.

THE WISSAHICKON CREEK. Another William Sliker image captures the Wissahickon Creek in the vicinity of Penllyn–Spring House. Here the creek resembles a tranquil pool located slightly upstream from a dam.

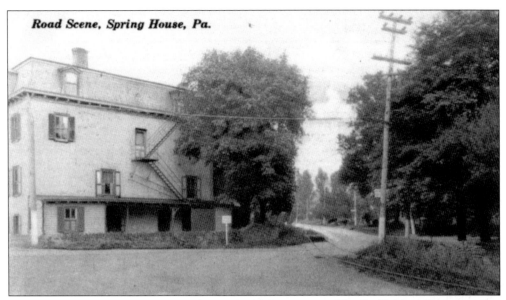

ROAD SCENE, SPRING HOUSE. Norristown Road, Sumneytown Pike, Bethlehem Pike, and Penllyn Pike all converge in the village of Spring House and create its oddly shaped main intersection. This *c.* 1920 view looks south on Bethlehem Pike from Sumneytown Pike, with the rear of the Spring House shown. The hotel dates back to the mid-1700s, but it was rebuilt after an 1888 fire. Trolley tracks from the Lehigh Valley Transit Company are faintly visible on the right.

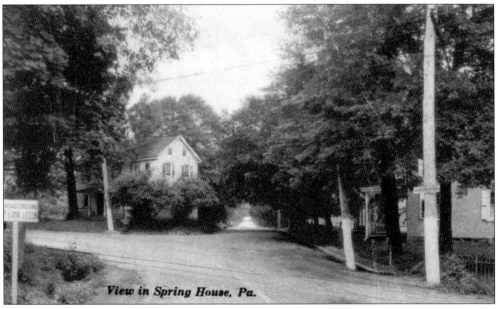

A VIEW IN SPRING HOUSE. Bethlehem Pike makes a sharp bend to the left around the rear of the Spring House (not shown in this view) in this scene looking south. Straight ahead is Penllyn-Blue Bell Pike, and the late-1800s Rempp family house is shown to the left. The house still stands, but this intersection has seen many changes in the past decades.

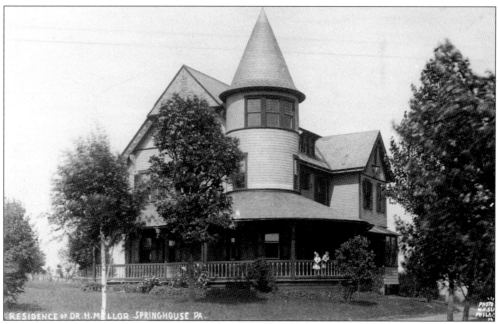

RESIDENCE OF DR. H. MELLOR, SPRING HOUSE. This beautiful country Victorian residence was the home of Dr. Howard Mellor of Spring House. The home dates from the late 1800s and stands on the east side of Bethlehem Pike atop Spring House Hill below Cedar Hill Road. The home stands today but has been extensively remodeled. William Sliker produced this postcard.

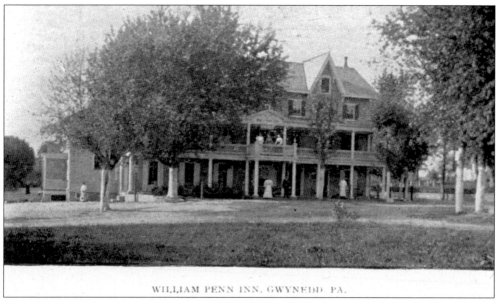

WILLIAM PENN INN, GWYNEDD, PA.

THE WILLIAM PENN INN, GWYNEDD. This is a *c.* 1900 view of the William Penn Inn in Gwynedd. A close inspection of this scene reveals people standing in front of the inn and on the second-floor balcony. Just as it was when it was built *c.* 1710, the William Penn Inn remains a popular place. The naming of the inn after Pennsylvania's founder, William Penn, commemorates his visit to Gwynedd *c.* 1700.

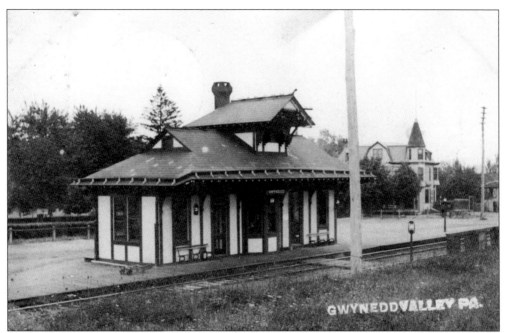

THE GWYNEDD VALLEY STATION. The North Pennsylvania Railroad originally erected the Gwynedd Valley Station in the mid-1800s. The depot's design was a bit different from most other stations. This Bartholomew postcard view from 1910 shows the Victorian Tudor design of the small station. The Gwynedd Valley store and post office building is in the background on Plymouth Road. Both structures still stand today.

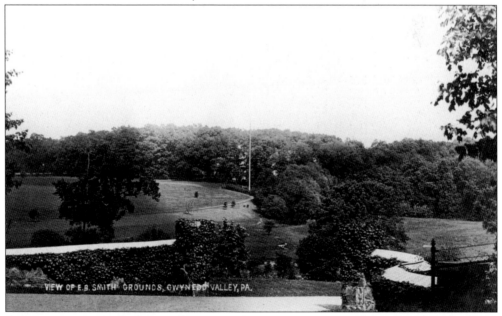

A VIEW OF THE E. B. SMITH GROUNDS, GWYNEDD VALLEY. This Miller postcard offers a sweeping view of Gwynedd Valley from atop Gypsy Hill Road at the Edward B. Smith residence. This view looks northwest toward the Wissahickon and Trewellyn Creeks. The house and much of the scenic grounds are still intact today.

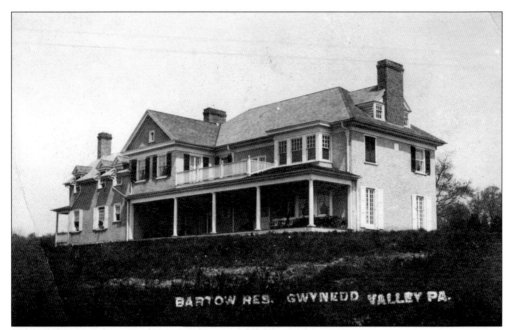

GWYNEDD VALLEY. Gwynedd Valley is a very scenic area in Montgomery County. Beautiful rolling hills and abundant streams, such as the Wissahickon Creek and the Trewellyn Creek, are found here. Gwynedd Valley was an attractive area to many wealthy individuals, who built extravagant estates amid the rolling hills and valleys. The view above, produced in 1909 by John Bartholomew, shows the Bartow residence on Gypsy Hill Road with its numerous chimneys, porches, and balconies. The 1910 Miller postcard view below shows a sloping valley in Gwynedd, with the Trewellyn Creek to the left and the Bartow residence to the right. Newer homes have been built in this area, but the Gwynedd Valley retains much of its country atmosphere.

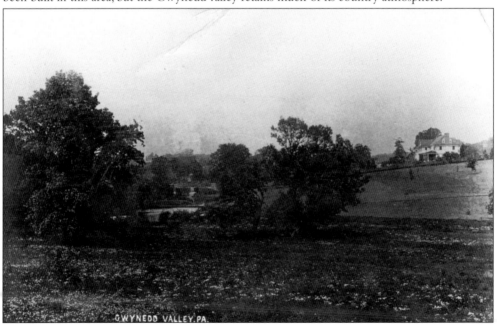

THE FRIENDS' SCHOOL, GWYNEDD. Plain and simple are words that describe the architecture of Quaker meetinghouses in the Philadelphia area. This simplistic style carried over to the schools the Friends built. The Gwynedd Friends' School was built in 1857 on the grounds of the Gwynedd Quaker meetinghouse, which dates to *c.* 1710. Though the school is no longer in use, the well-preserved building still stands on the property. Active Friends schools still exist in Plymouth Meeting, Abington, and Germantown.

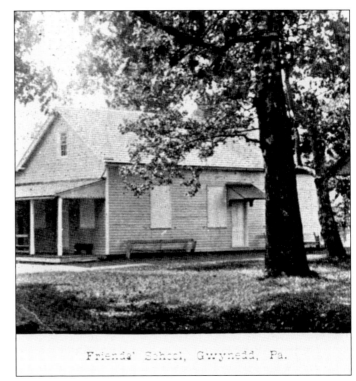

Friends' School, Gwynedd, Pa.

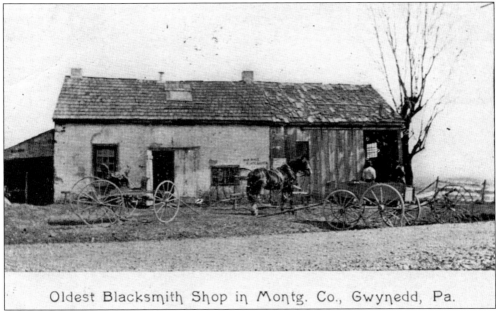

Oldest Blacksmith Shop in Montg. Co., Gwynedd, Pa.

BLACKSMITH SHOP, GWYNEDD. A likely location for a colonial blacksmith shop in Gwynedd would have been across the road from the prominent Gwynedd Friends meetinghouse. Gwynedd was sparsely settled in the 1700s, and the Quakers had to travel to the meetinghouse. A blacksmith shop would have been necessary for the repair and maintenance of carriages and horse gear and would have been well patronized. This 1905 view shows the shop, with a few people, most likely customers, on the property. This building still stands and has been altered for residential use.

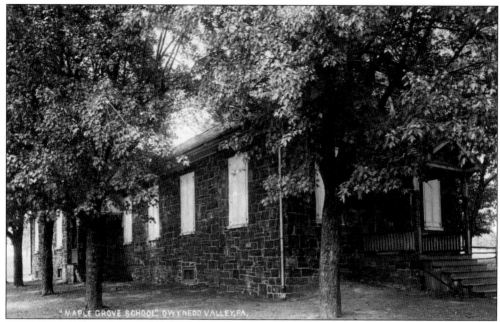

THE MAPLE GROVE SCHOOL, GWYNEDD VALLEY. Throughout the 1800s, public schools were erected all over Montgomery County. The Maple Grove School, built in 1877, is a typical early school building. Constructed of native stone, the school has had several additions. The building, seen on this Miller postcard, has been converted to a residence and is still standing on Plymouth Road in Lower Gwynedd Township.

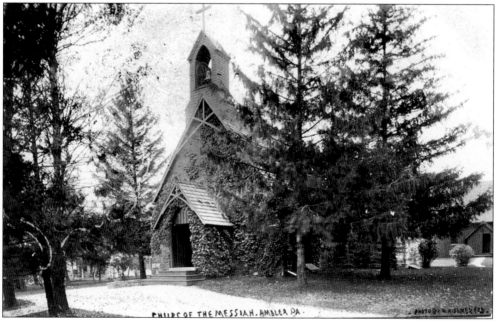

THE CHURCH OF THE MESSIAH, GWYNEDD. The Church of the Messiah, seen on this Sliker postcard, is an Episcopal church located on DeKalb Pike south of the William Penn Inn in Gwynedd. The church was built in 1871, and additions were made in 1926 and 1991. This building remains a good example of late-19th-century rural church architecture in Montgomery County.

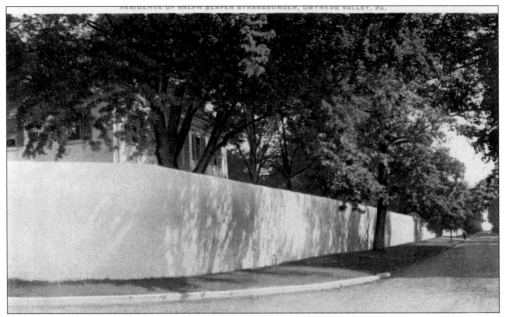

NORMANDY FARM WALLS ALONG STATE ROAD, GWYNEDD VALLEY. Familiar sights along Route 202 near Gwynedd Valley are the large white walls that surround the former Normandy Farm complex at Morris Road. At the junction of State Road (DeKalb Pike) and Morris Road was the village of Franklinville. The village at one time contained a few buildings, including the Franklinville Inn, which is shown here on the left. The inn, built in 1834, still stands, as do the distinctive white walls. Ralph Beaver Strassburger, who married into the wealthy Singer Sewing Machine family, owned Normandy Farms. He would later own the Norristown Times Herald.

THE WISSAHICKON CREEK, NORTH WALES. The Wissahickon is one of a few scenic streams that wind their way through eastern Montgomery County. William Sliker photographed the Wissahickon Creek in 1910 from a vantage point on the North Wales Road (Walnut Street) bridge. Beautiful reflections are seen in this lovely country view.

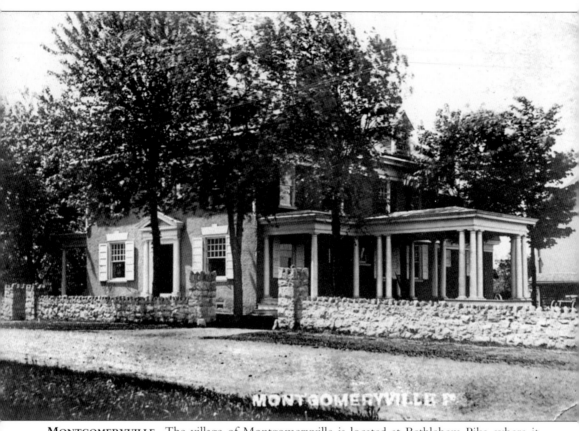

MONTGOMERYVILLE

MONTGOMERYVILLE. The village of Montgomeryville is located at Bethlehem Pike, where it crosses Horsham Road and Doylestown Road at five points. A few old structures remain in this busy area. Much of this area has changed due to the widening of many roads and increased development. This 1908 postcard by John Batholomew of Lansdale shows a house in Montgomeryville. The beautiful home appears to be constructed in the Colonial Revival style, which is rather impressive for a country farmhouse. An old barn can be seen in the rear of the home. The author has been unable to locate this home or to uncover any information about its history.

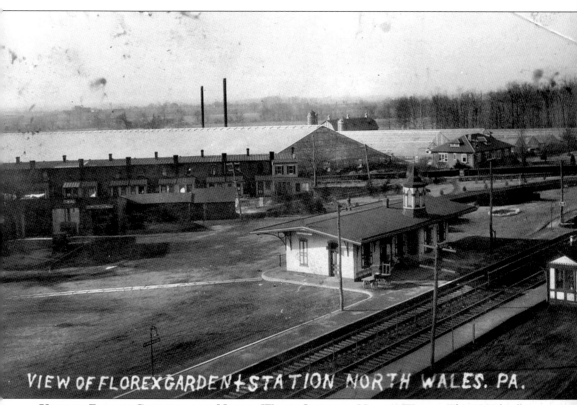

VIEW OF FLOREX GARDEN + STATION NORTH WALES. PA.

VIEW OF FLOREX GARDENS AND NORTH WALES STATION, NORTH WALES. This 1909 bird's-eye view reveals a nice panoramic scene looking northwest toward the North Wales train station. The station, built in 1873 on the old North Pennsylvania Railroad line, is shown in the center. The large Florex Gardens, noted growers of roses, carnations, and other plants, is shown beyond the station. The most outstanding feature in this view is the immense size of one of the greenhouses shown in the upper left. The station is still in use, but nothing remains of Florex Gardens.

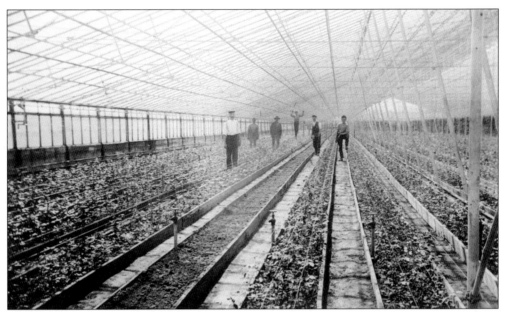

FLOREX GARDENS, NORTH WALES. Lansdale photographer John Batholomew captured the interior of one of the large greenhouses at the Florex Gardens complex. Three men started the business in 1907, and it remained in operation until the middle of the 20th century. The greenhouse operations were located directly along the rail line and within walking distance of the North Wales station, which made transporting products simpler.

THE WISSAHICKON, NORTH WALES. A single-track railroad bridge passes over a rather narrow Wissahickon Creek near North Wales on this *c.* 1908 John Bartholomew postcard.

Six

THE SCHUYLKILL RIVER CORRIDOR

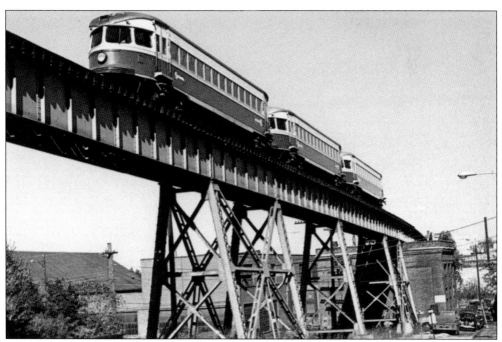

THE RED ARROW LINE, BRIDGEPORT. This view from 1971 shows Septa's Red Arrow bullet train cars on the Bridgeport trestle spanning the Schuylkill River between Bridgeport and Norristown. Originally part of the Philadelphia & Western Railway (P&W), the line first opened in 1912 between 69th Street in Upper Darby and Norristown.

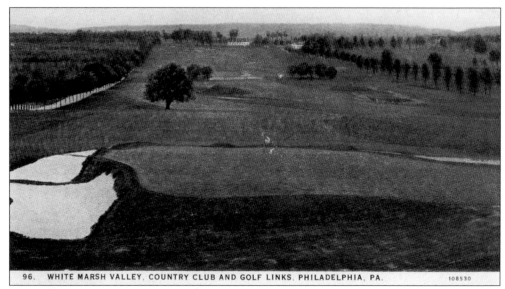

96. WHITE MARSH VALLEY, COUNTRY CLUB AND GOLF LINKS, PHILADELPHIA, PA. 108530

THE WHITEMARSH VALLEY COUNTRY CLUB AND THE GOLF LINKS. George Thomas's Bloomfield Farm in Lafayette Hill became the Whitemarsh Valley Country Club in April 1908. Situated in the beautiful Whitemarsh Valley along Germantown Pike and Thomas Road, the club has a long history of hosting various golf invitationals. Part of the property borders the Wissahickon Creek and the Morris Arboretum; together they form a large expanse of beautiful open space rarely found in this part of the county. This 1920 view appears to show the club grounds, with Thomas Road to the left.

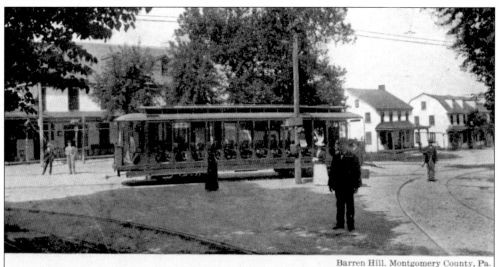

Barren Hill, Montgomery County, Pa.

BARREN HILL. Horse-drawn trolleys on the Roxborough-Barren Hill line operated from the 1850s until electric cars were installed sometime before 1900. This view from 1905 shows an open-ended summer trolley turning on Church Road from Germantown Pike in Barren Hill, now known as Lafayette Hill. Behind the trolley can be seen the 1732 General Lafayette Inn, originally called the Three Tun Tavern. During the Revolutionary War, there was a battle between the Continental and British troops in an area west of this village known as Barren Hill. The well-known and much admired General Lafayette oversaw military operations during that battle. Barren Hill was renamed Lafayette Hill in his honor.

ST. PETER'S LUTHERAN CHURCH, LAFAYETTE HILL. Located on Church Road between Germantown and Ridge Pikes in Whitemarsh Township is St. Peter's Lutheran Church. Noted Lutheran Dr. Henry Muhlenberg founded the historic church in 1752. The first church was built in 1767 and was used as a meeting place during the Revolutionary War by members of the Continental army, including General Lafayette. In 1899, the church was destroyed by a fire. It was rebuilt in 1900 and featured a tall spire, as shown in the top view from 1905. During the 1900s, the church was altered, and the steeple was removed, as shown in the view below. A new steeple was installed several years ago.

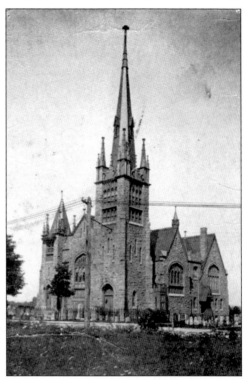

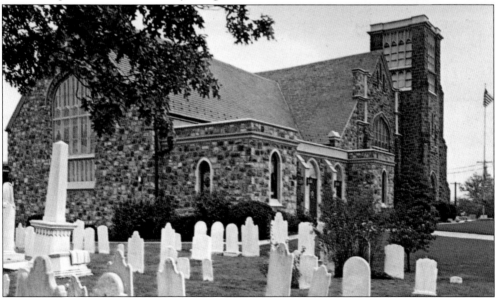

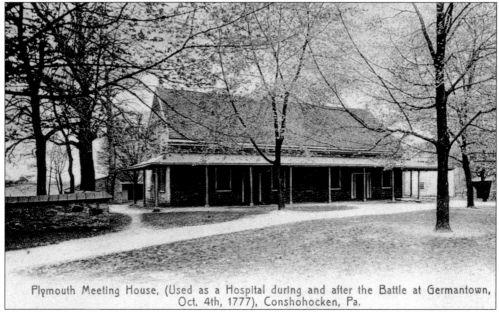

Plymouth Meeting House, (Used as a Hospital during and after the Battle at Germantown, Oct. 4th, 1777), Conshohocken, Pa.

THE PLYMOUTH MEETINGHOUSE, PLYMOUTH MEETING. The Quakers were the first organized religious group to settle in William Penn's land in the late 1600s. Many of Montgomery County's Quaker meetings were established at that time, including the Plymouth Meeting. Although the first meetinghouse at Plymouth was built *c.* 1704, worshiping was taking place in private homes *c.* 1686. Shown in this 1905 Graham & Johnson postcard view is the Plymouth Meetinghouse that was built in 1867 after a fire had destroyed the original structure. Still active today, the meetinghouse stands at the center of this historic community.

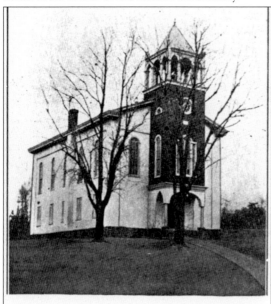

COLD POINT. NEAR CONSHOHOCKEN, PA.

Established 1854 this is one of the early and most picturesque churches of Whitemarsh Township.

THE COLD POINT BAPTIST CHURCH, NEAR CONSHOHOCKEN. Those who travel around Plymouth or Whitemarsh at night may see the beautifully illuminated Cold Point Baptist Church sitting high atop Cold Point Hill. This church, founded in 1854, was a branch of the Chestnut Hill Baptist Church of Philadelphia. This structure dates from the 1860s. The village of Cold Point contains many old buildings and is situated a mile north of Plymouth Meeting along Butler Pike.

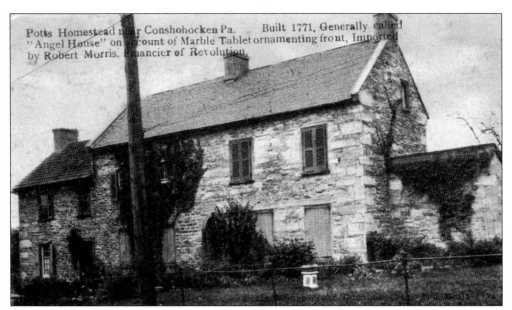

Potts Homestead near Conshohocken Pa. Built 1771, Generally called "Angel House" on account of Marble Tablet ornamenting front, Imported by Robert Morris, Financier of Revolution.

THE POTTS HOMESTEAD, HARMONVILLE, CONSHOHOCKEN. The village of Harmonville was located at the crossroads of Butler and Ridge Pikes in Whitemarsh and Plymouth Townships. Named after storekeeper Harman Yerkes, Harmonville is now part of the Conshohocken postal area. The Potts home, shown in this Graham & Johnson postcard view, stood in Harmonville and was often referred to as the "Angel House." Though not visible here, a marble sculpture slab with a carved angel was placed on the front of the home near the second window from the right on the second floor. This marble tablet was supposedly rescued from Robert Morris's lavish Philadelphia home that was demolished in the 1800s.

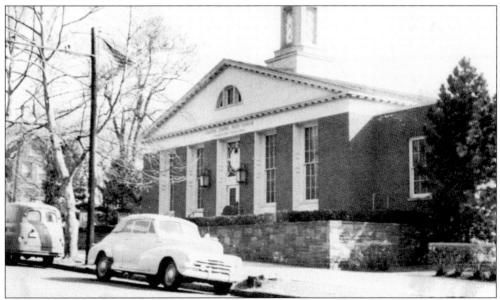

THE POST OFFICE, CONSHOHOCKEN. This Art-Glo postcard view from *c.* 1952 shows the Conshohocken post office, built in 1940. The handsome Colonial Revival building still serves as the post office at Fifth Avenue and Fayette Street. The post office contains a nice interior with richly embellished walls.

THE OLD SPRING MILL, NEAR CONSHOHOCKEN. One of the most widely known mills in colonial Pennsylvania was Spring Mill, located along Spring Mill Creek near the Schuylkill River. Two separate Spring Mill Roads, located in Lower Merion and Whitemarsh, once led to the mill, which was built in the early 1700s. This 1906 Graham & Johnson postcard view shows the mill on the right and the miller's house to the left. Farmers from the surrounding communities brought their grain to this mill for grinding. The mill no longer stands, but the house may still be seen on Hector Street at North Lane.

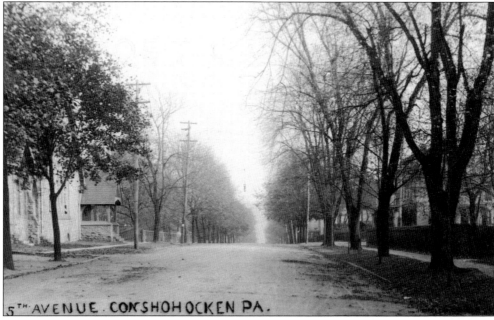

5TH AVENUE CONSHOHOCKEN PA.

FIFTH AVENUE, CONSHOHOCKEN. This rare Sliker postcard view provides a glimpse of Fifth Avenue at Harry Street in Conshohocken. Shown in this view is a wide dirt street lined with trees and large homes. The building on the left is a portion of St. Marks Evangelical Church, which dates back to the 1890s. One characteristic of Conshohocken is the very wide streets, which are evident here.

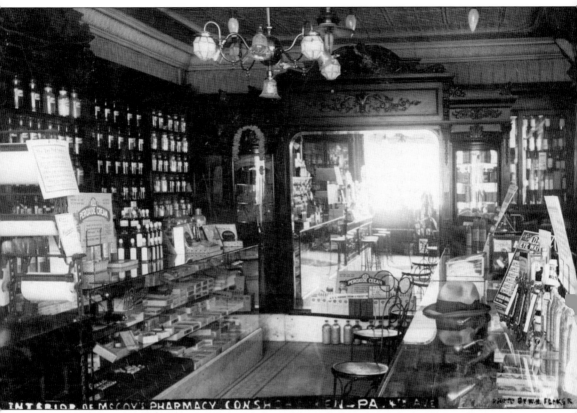

THE INTERIOR OF MCCOY'S PHARMACY, CONSHOHOCKEN. This William Sliker postcard captures a rare look at the interior of McCoy's Pharmacy in Conshohocken. Early postcards with local interior views are quite scarce. This scene details the shelving, woodwork, lighting, medicines, and merchandise in the pharmacy about 100 years ago. The reflection in the mirror gives the viewer a real sense of the depth of the entire store. The row of stools along the counters indicates that the pharmacy most likely contained a soda or ice-cream fountain. McCoy produced a popular series of postcard views of Conshohocken, but it was Sliker who published this view.

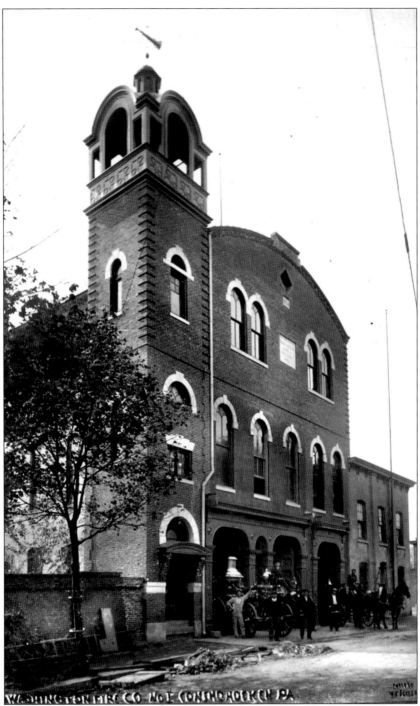

WASHINGTON FIRE COMPANY NO. 1, CONSHOHOCKEN. The Washington Fire Company dates back to the 1870s. This building, located on Hector Street west of Fayette Street, dates from that early time, but a few additions were made in the late 1800s and the early 1900s. This early Sliker postcard view shows numerous firemen, with their equipment and horses, posing in front of the building, which still stands today. Currently, a modern facility on Elm Street houses the fire company.

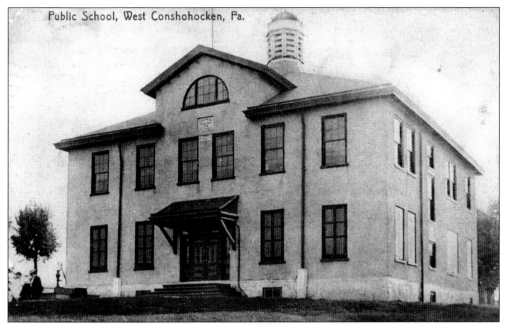

Public School, West Conshohocken, Pa.

A Public School, West Conshohocken. The borough of West Conshohocken was incorporated in 1874. The public school was built in 1875 and was expanded in the 1880s. A fire in 1903 caused major damage to the school, and the building was rebuilt. Often referred to as the Bullock Public School, it was named after West Conshohocken's first burgess, George D. Bullock. The school, located at Bullock and Moir Avenues, continued to operate in this building through the 1920s. It was torn down in 1951. This postcard was published by Graham & Johnson.

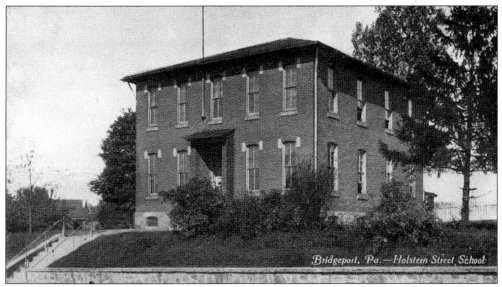

Bridgeport, Pa.—Holstein Street School

Holstein Street School, Bridgeport. The Holstein Street School, seen in this 1906 World Postcard Company view, was built in 1882 in the borough of Bridgeport on Holstein Street below Ford Street. Bridgeport was incorporated in 1851, and the borough had several schools, including its own high school. Today Bridgeport is served by the Upper Merion School District.

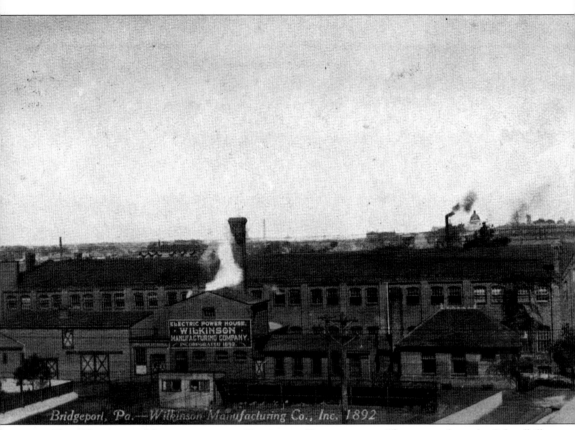

Bridgeport, Pa.—Wilkinson Manufacturing Co., Inc. 1892

THE WILKINSON MANUFACTURING COMPANY, BRIDGEPORT. The towns along the Schuylkill River, including Bridgeport, have a long history of industrial prominence. In the early 1800s, the Schuylkill Navigational Canal was opened, and in 1839 the railroad extended to Bridgeport. These early transportation systems aided in the development of industry in Bridgeport. Factories producing a wide range of products from cotton and iron were established here. This 1907 World Postcard Company view shows the large Wilkinson Manufacturing Company plant along the Schuylkill. The company was established in 1892.

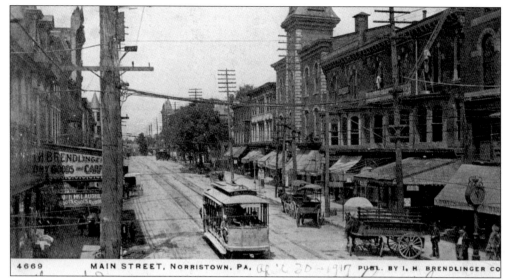

4669 MAIN STREET, NORRISTOWN, PA, *[handwritten]* PUBL. BY I. H. BRENDLINGER CO

MAIN STREET, NORRISTOWN. The county seat of Montgomery County and its biggest and busiest borough, Norristown has been a center of commerce and government since the late 1700s. This 1906 view shows a glimpse of downtown Norristown along Main Street. A trolley passes horse-drawn carriages, and a wide variety of businesses and stores lines both sides of the street for many blocks. To the left is an awning over the I. H. Brendlinger dry goods store. Brendlinger sold a variety of goods in his store and also published local postcards of Valley Forge, Audubon, and Norristown, including this view.

A VIEW ON DEKALB STREET, NORRISTOWN. DeKalb Street is one of the main arteries running north to south through Norristown. DeKalb Street stretches north above the business area and the courthouse. Large, beautiful homes were built here in the late 1800s and early 1900s, as shown on this 1915 postcard. Many of these homes, with styles ranging from Victorian to Colonial Revival, still stand.

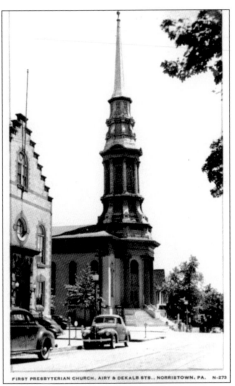

THE FIRST PRESBYTERIAN CHURCH, NORRISTOWN. This 1940s view shows Norristown's First Presbyterian Church on Airy Street at DeKalb Street. One of Montgomery County's most beautiful churches, the landmark building, with its very tall and graceful steeple, has dominated Norristown's skyline for over 100 years. The church was founded in the early 1800s, but this building dates from the 1850s. Shown to the left is a portion of Norristown's borough hall, which is no longer standing.

FIRST PRESBYTERIAN CHURCH. AIRY & DEKALB STS., NORRISTOWN, PA. N-273

ST. PATRICK'S ROMAN CATHOLIC CHURCH, NORRISTOWN. Norristown is Montgomery County's largest town, and it contains many beautiful churches. St. Patrick's Roman Catholic Church is located on the east side of DeKalb Street at Chestnut Street. The church was founded in 1836. This building contains beautiful stonework, Greek-style columns, a Classical Revival pediment at the upper roof, and Romanesque arches and windows. The church still stands on one of Norristown's busiest streets.

98

Seven

THE MAIN LINE
TO VALLEY FORGE

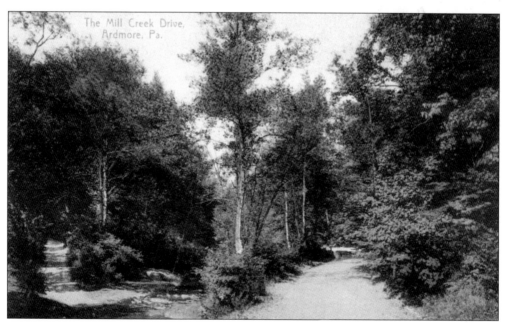

THE MILL CREEK DRIVE, ARDMORE. Shown on this Philip Moore postcard is Old Gulph Road looking north above Mill Creek Road in Lower Merion Township. In 1907, Gulph Road was a narrow dirt road that paralleled Mill Creek.

THE BLACK HORSE INN, OVERBROOK. The historic Black Horse Inn, seen in this World Postcard Company image, stood on Lancaster Pike immediately west of City Line Avenue in Lower Merion Township. Dating to *c.* 1720, the Black Horse is reputed to be the site of a Revolutionary War skirmish between the Continental army and the British troops in 1777. An account of the skirmish states that the Pennsylvania Militia defeated a small British army under Lord Cornwallis, and the injured and the dead were moved to the Black Horse barn located behind the inn. The Black Horse Inn was demolished *c.* 1920.

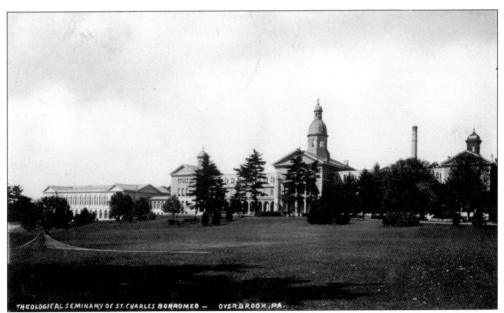

THE ST. CHARLES BORROMEO SEMINARY, OVERBROOK. Situated at Lancaster and City Line Avenues in Lower Merion Township is the St. Charles Borromeo Seminary. Rev. Francis Kendrick, then the bishop of Philadelphia, founded the seminary in 1832 in Philadelphia. The main building, seen on this Sliker postcard, was built in the 1870s and was designed by architects Addisson Hutton and Samuel Sloan. Theology is taught inside the beautiful buildings on the large property.

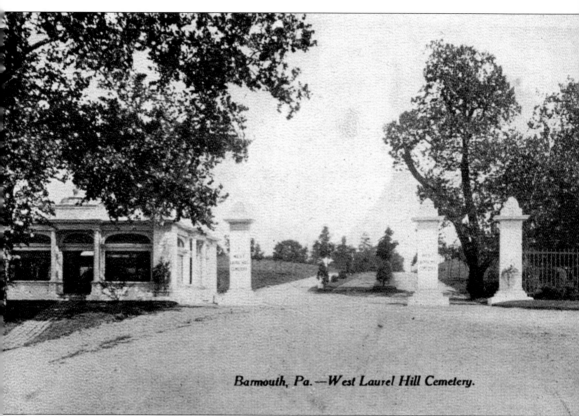

Barmouth, Pa.—West Laurel Hill Cemetery.

WEST LAUREL HILL CEMETERY, BARMOUTH. Barmouth is a curious name, not known by many, which is derived from the name of a town in Wales. Many of Lower Merion's earliest families came from Wales in the 1600s and 1700s. Barmouth actually refers to the name of a train station along the Pennsylvania Railroad that was formerly called West Laurel Hill Station. The station was created as a stop for the 197-acre West Laurel Hill Cemetery, established in 1869. In the 1800s and early 1900s, cemeteries were frequently visited by the public, which created the need for the station. One interesting aspect about West Laurel Hill is that it contains the grave of Anna Jarvis, the founder of Mother's Day. This postcard was published by World Postcard Company.

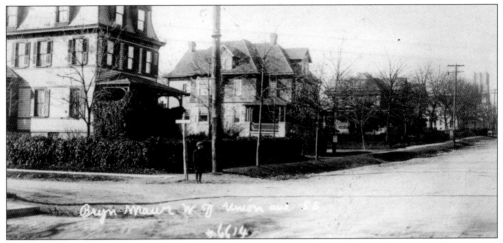

BRYN MAWR AVENUE, BALA. This Merchantile Studios postcard view from 1910 shows Bryn Mawr Avenue looking west from Union Avenue in Bala, just a few blocks west of City Line Avenue. The home on the corner at the left is no longer standing, but most of the other homes remain. This is a great view of a typical streetscape in Bala. Today two town names have been combined into one, and this area is referred to as Bala-Cynwyd. Both Bala and Cynwyd were named after towns in Gwynedd, Wales.

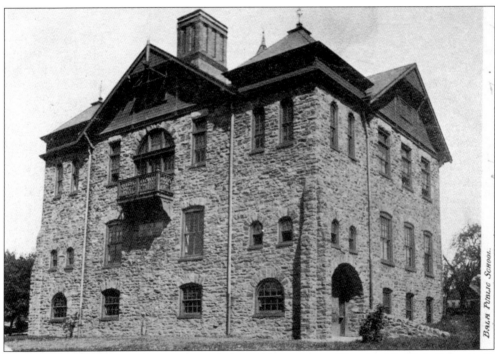

BALA PUBLIC SCHOOL. A fine example of a late-19th-century public school is this building, built in 1888. In Lower Merion, each community had its own school. The Bala school stood at Bala and Union Avenues. It was demolished in the 1970s, when large regional schools were used. This postcard was published by World Postcard Company.

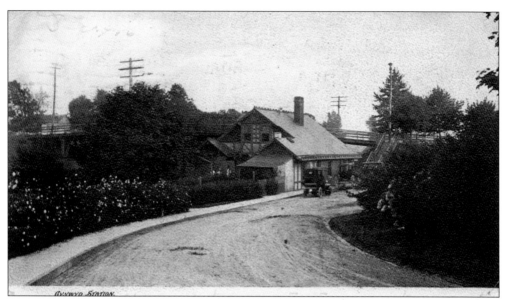

CYNWYD STATION, CYNWYD. This 1905 World Postcard Company view shows the Cynwyd Station from the driveway off Conshohocken State Road. Both the driveway and the station remain. Cynwyd Station was first used in 1884.

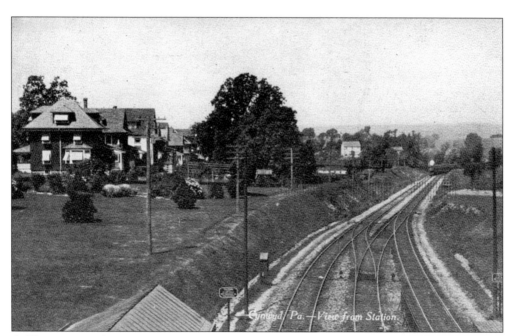

A VIEW FROM CYNWYD STATION, CYNWYD. From a vantage point atop the Montgomery Avenue Bridge, this World Postcard Company scene shows the top of Cynwyd Station at the lower left. Large homes that back up to the railroad are situated on Conshohocken State Road.

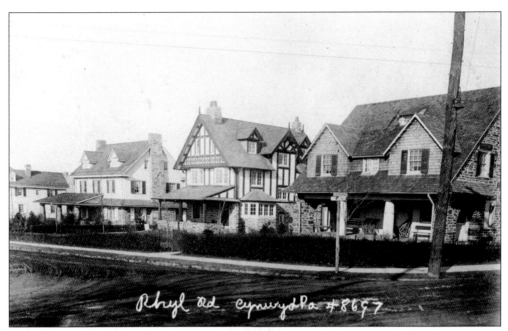

RHYL ROAD, CYNWYD. The Merchantile Photographic Studio from West Philadelphia produced many postcards of Philadelphia neighborhoods and some of the nearby suburbs, such as this scene from 1910. Here is Rhyl Road looking north from Righters Ferry Road. Varying architectural styles, from English Tudor to Colonial Revival, are present here. These homes still stand.

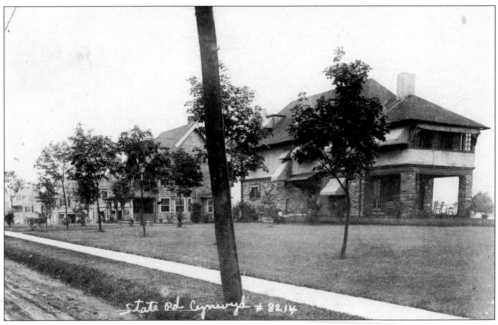

STATE ROAD, CYNWYD. Beautiful single homes, each individual in style, are shown along Conshohocken State Road west of Montgomery Avenue in Cynwyd on this Merchantile postcard.

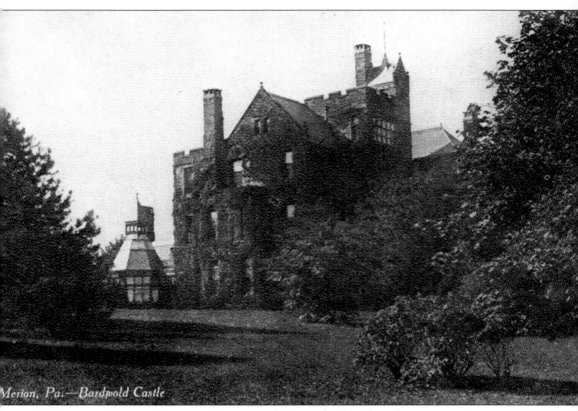

Merion, Pa.—Bardwold Castle

BARDWOLD CASTLE, MERION. Montgomery County has long been home to many extravagant and lavish mansions built in varying architectural styles. A prime example is Bardwold Castle, which was constructed by Matthew Baird and was once located on 30 acres along Baird Road near the Merion train station. Baird, who lived from 1817 to 1877, was the proprietor of the enormous Baldwin Locomotive Works in Philadelphia. The neighborhood around Merion still contains a fine collection of Tudor and Colonial Revival mansions erected over 100 years ago by wealthy industrial barons. This postcard was published by World Postcard Company.

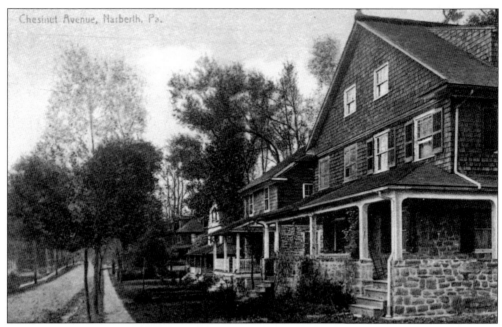

CHESTNUT AVENUE, NARBERTH. Narberth Borough contains many different styles of homes on rather small streets, as shown in this 1912 Philip Moore postcard view of Chestnut Avenue west of Essex Avenue. These homes still stand.

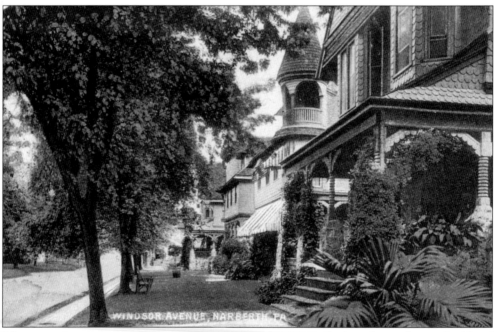

WINDSOR AVENUE, NARBERTH. This Philip Moore postcard view shows the north side of Windsor Avenue west of Essex Avenue. There are very few identical homes on this block and throughout Narberth. These homes still stand, but with some alterations.

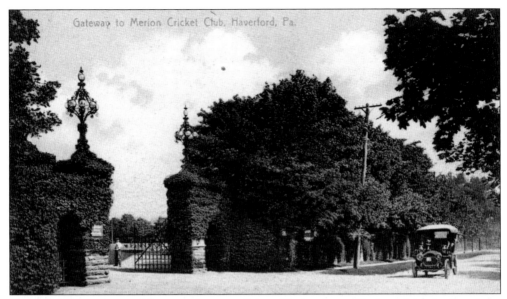

THE GATEWAY TO THE MERION CRICKET CLUB, HAVERFORD. Playing cricket has long been a tradition in the Main Line. Students from Haverford College first played the game back in the 1830s. A cricket club was first organized in the mid-1800s. It was housed at various locations in Wynnewood and Ardmore (near Cricket Lane) and eventually moved to this site along Montgomery Avenue in Haverford. The club buildings generally date back to the 1890s. The gate and entrance shown in this 1908 Philip Moore postcard view still stand.

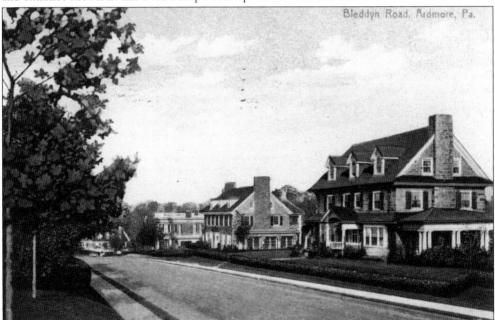

BLEDDYN ROAD, ARDMORE. Large stone homes lined Bleddyn Road off Montgomery Avenue in Ardmore, Lower Merion Township. In this 1912 Philip Moore postcard view, the homes look recently constructed. These homes still stand today, but many have large trees surrounding them. Bleddyn Road is a prime example of an upper-middle-class neighborhood constructed on the Main Line.

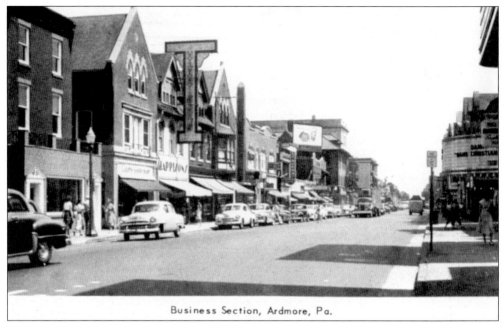

Business Section, Ardmore, Pa.

THE BUSINESS SECTION, ARDMORE. This Charles Seeman postcard from the early 1950s shows the business district in Ardmore along Lancaster Avenue, looking east from Ardmore Avenue. The large grouped building with the T-shaped sign was built *c.* 1880 as William Lesher's general store. Ardmore still retains an interesting collection of stores.

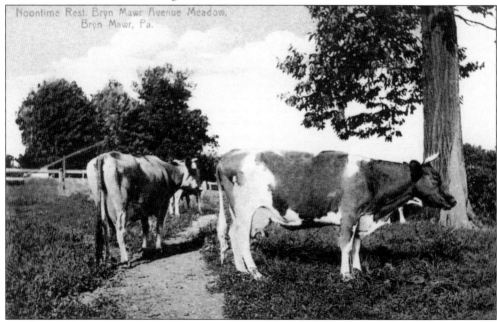

Noontime Rest. Bryn Mawr Avenue Meadow, Bryn Mawr, Pa.

NOONTIME REST, BRYN MAWR AVENUE MEADOW, BRYN MAWR. This 1909 Philip Moore postcard clearly illustrates the rural character of eastern Montgomery County in the early 1900s, even in a location very close to the city. Cows are shown in a meadow along Bryn Mawr Avenue near Bryn Mawr in Lower Merion Township. Farms have been disappearing from the county's landscape since the mid-1900s.

108

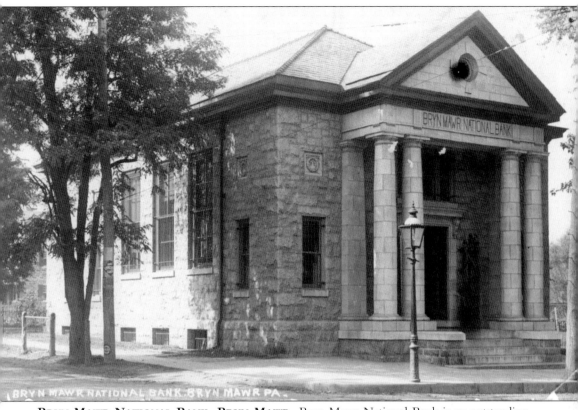

BRYN MAWR NATIONAL BANK, BRYN MAWR. Bryn Mawr National Bank is an outstanding example of late-19th-century bank architecture. The bank was founded in 1887, and this solid stone, vaultlike structure with massive columns was built. This building once stood on Lancaster Avenue near Bryn Mawr Avenue. In 1928, the bank merged with the Bryn Mawr Trust Company. It is still in existence today. William Sliker produced this postcard.

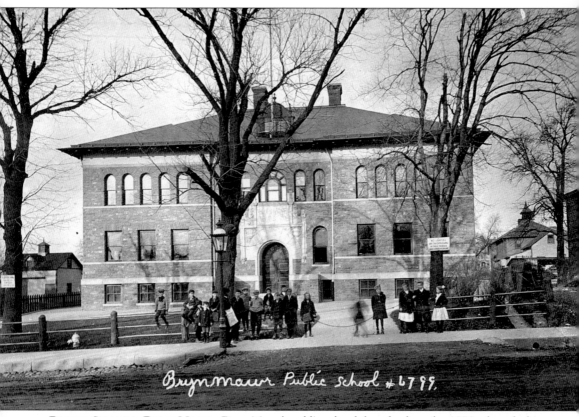

Brynmawr Public School # 6799.

PUBLIC SCHOOL, BRYN MAWR. Bryn Mawr's public school dates back to the 1850s, though this building was built in the late 1800s. The school stood on Lancaster Avenue at Prospect Street and was used into the early 1900s. Larger, more modern schools were built in Lower Merion, and this building was torn down in 1936. This Merchantile Studios postcard from 1908 shows the school and some students on the sidewalk.

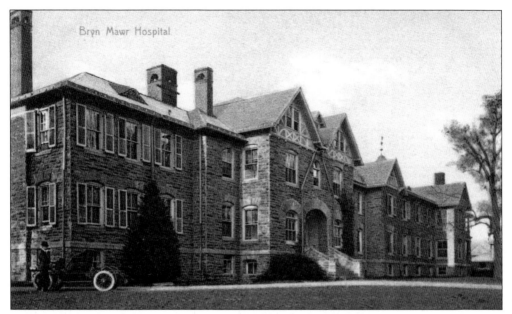

BRYN MAWR HOSPITAL. Dr. George S. Gerhard founded Bryn Mawr Hospital in 1892. The original hospital building is on the left on this Philip Moore postcard, and additions to the building are shown to the right. Today the hospital is located on Bryn Mawr Avenue and contains many larger buildings. It continues to serve the Main Line.

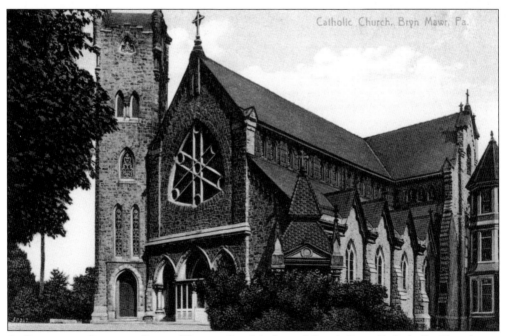

A CATHOLIC CHURCH, BRYN MAWR. Our Mother of Good Council Catholic Church was established in 1885. This church was built in 1896 and was designed by architect Edwin F. Durang in the Gothic style. Durang was born in New York City, but he spent his career in Philadelphia. He specialized in Catholic church architecture, designing many local churches. This beautiful structure still stands. Philip Moore published this postcard.

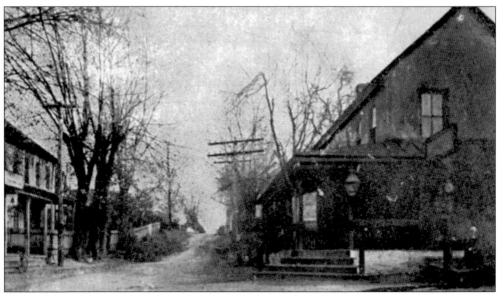

THE GENERAL STORE, POST OFFICE, AND HOTEL, GLADWYNE. Prior to 1890, Gladwyne was known as Merion Square. This 1905 view looks east on Righters Mill Road from Youngs Ford Road and shows the center of Gladwyne. On the left is the post office and Isaac Cornman's general store, built in 1890. To the right is the old Merion Square Hotel, which dates to 1810. Gladwyne's buildings date to *c.* 1800, but many of the surrounding mills and homes date to *c.* 1700. This area is now part of the Gladwyne (Merion Square) Historic District.

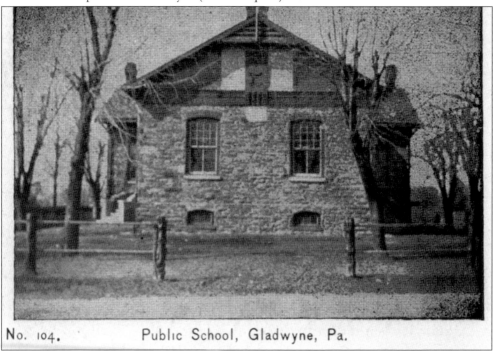

No. 104. Public School, Gladwyne, Pa.

PUBLIC SCHOOL, GLADWYNE. The old Merion Square School in Gladwyne, which dates to 1880, is shown in this 1905 view. The building still stands on Youngs Ford Road and currently contains a private school. Gladwyne retains many of its older buildings.

112

OLD GULPH ROAD, GULPH MILLS. This 1905 World Postcard Company view looks south on Old Gulph Road, with Hanging Rock on the left. Gulph Creek is shown to the right; it powered Gulph Mills, which gave the area its name. Hanging Rock still stands along this stretch of road. Gulph Road, dating to the late 1600s, was an important colonial highway and was noted as the route that George Washington and his army used to travel to Valley Forge.

VALLEY FORGE. This beautiful scene shows Valley Creek at Valley Forge in 1907. In this view, a footbridge crosses the creek near Gen. Henry Knox's headquarters, now known as Valley Forge Farm. Hikers in Valley Forge National Historical Park can still walk across this bridge.

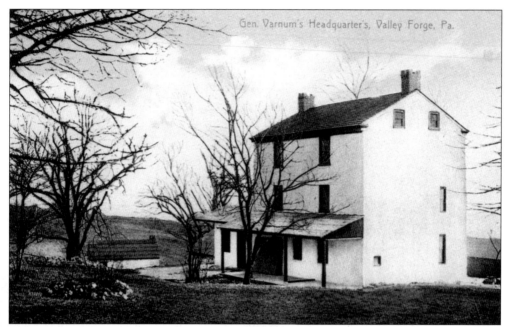

VALLEY FORGE NATIONAL HISTORICAL PARK. Valley Forge National Historical Park is situated in Chester and Montgomery Counties. The park preserves the grounds where George Washington and his Continental army established encampments from December 1777 to June 1778. Two historic farms that served as headquarters for the army's generals are located in the Montgomery County portion of the park. The top view shows a home that was the headquarters of Gen. James Varnum of Rhode Island. This home is still standing, but it has been restored to its original appearance and looks different than this 1908 view. The home shown below was the headquarters of Gen. Jedediah Huntington of Connecticut, and it is still standing in the park east of Varnum's headquarters. Both homes were built in the mid-1700s. These postcards were published by Samuel Parker.

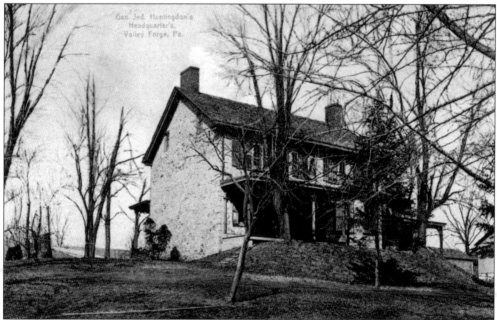

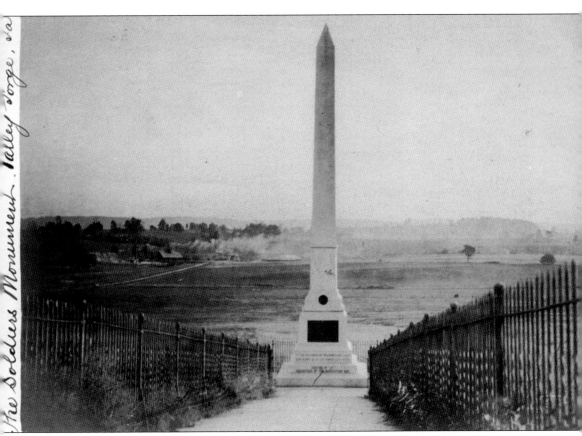

THE SOLDIERS MONUMENT, VALLEY FORGE. Along Valley Forge Road (Route 23) near the Washington Memorial Chapel stands this monument. Called the Waterman Monument, it is supposedly the only known grave site at Valley Forge, and it is named for Commissary Officer Waterman, who was part of General Varnum's unit. The 40-foot monument can still be seen in the park today. This real-photo postcard is from 1908.

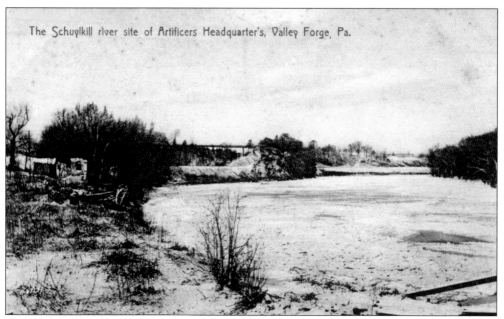

The Schuylkill river site of Artificers Headquarter's, Valley Forge, Pa.

THE SCHUYLKILL RIVER, VALLEY FORGE. These views show a snowy landscape in Valley Forge. Perhaps Samuel Parker, the publisher of these postcards, was attempting to evoke images of the snowy, cold winter of 1777–1778, when George Washington and the Continental army camped at Valley Forge.

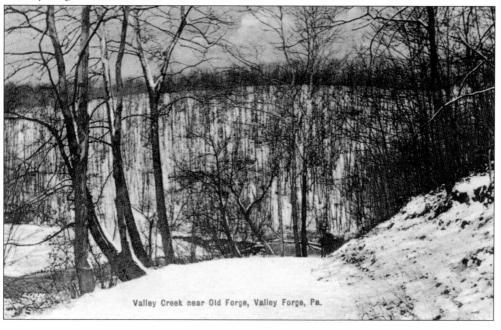

Valley Creek near Old Forge, Valley Forge, Pa.

MOUNT JOY, VALLEY FORGE. This real-photo postcard from 1908 shows a view near the summit of Mount Joy at Valley Forge. Mount Joy in Montgomery County and Mount Misery in Chester County mark the highest hills at Valley Forge. The original name for the forge located here was Mount Joy Forge. The name was later changed to Valley Forge; it was named for Valley Creek, which flows between the two hills. At one time there was a 75-foot steel observation tower on Mount Joy that offered wonderful views of the park. The tower was demolished in the 1960s.

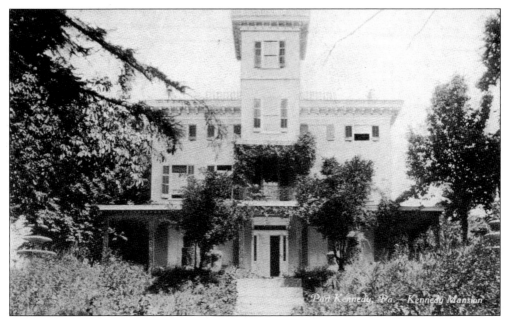

PORT KENNEDY. East of Valley Forge once stood the village of Port Kennedy along the Schuylkill River. John Kennedy, son of Irish immigrants, was born in 1815 and lived in the area. He developed Port Kennedy into a thriving small village with wharfs along the Schuylkill. In 1852, he and his wife built Kenhurst, shown above. This building is one of only a few still standing in Port Kennedy. The view below shows Loughlin's Hotel, built in the mid–1800s. This building is no longer standing. Many structures in Port Kennedy were demolished for the construction of the Route 422 expressway. World Postcard Company published these postcards.

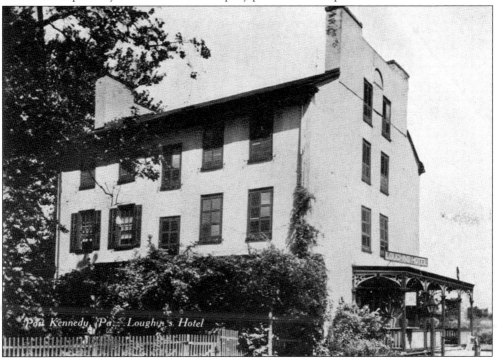

Eight

BLUE BELL, JARRETTOWN, AND OTHER VILLAGES

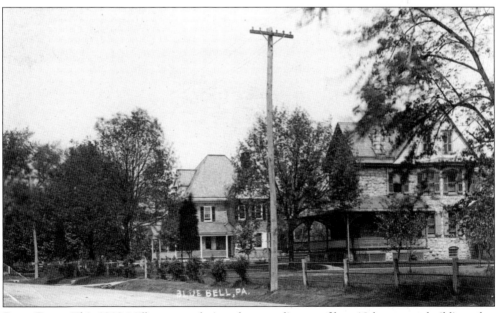

BLUE BELL. This 1910 Miller postcard view shows a glimpse of late-19th-century buildings that stood on Skippack Pike east of Penllyn-Blue Bell Pike. There are currently buildings dating to the 1700s still standing in Blue Bell; however, the structures shown here are gone.

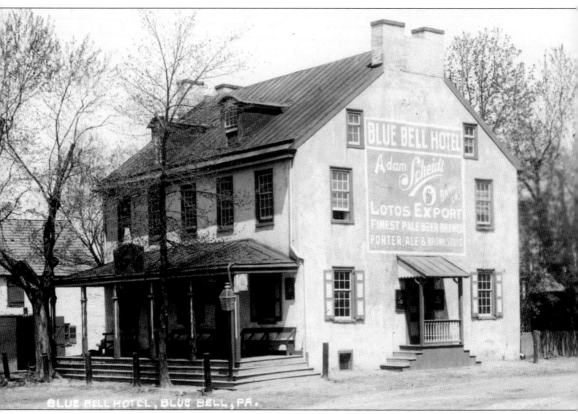

BLUE BELL HOTEL, BLUE BELL, PA.

THE BLUE BELL HOTEL, BLUE BELL. This building is said to date to 1743 and was originally called the White Horse Inn. When the Blue Bell post office was established in 1840, this structure became known as the Blue Bell Hotel. This Miller postcard view from 1908 shows the old hotel with many of its early features, including porches and doorways not found on the present structure, which still operates as an inn at the corner of Skippack Pike and Penllyn-Blue Bell Pike. Of special note is the nice advertisement of the side of the building for Adam Scheidt Beer of Norristown.

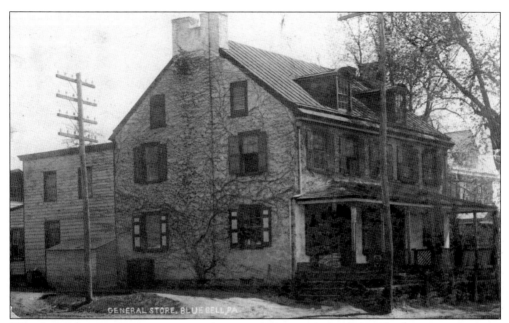

THE GENERAL STORE, BLUE BELL. The general store in Blue Bell dates back to the early 1800s. The Blue Bell post office was established in this building in 1840 and remained here until 1960, when a larger facility was built at another site. In this Miller postcard view, it is interesting to note how similar this building looks to the Blue Bell Hotel, which was located directly across Penllyn Pike. Unlike the hotel, which still stands today, this building has been torn down.

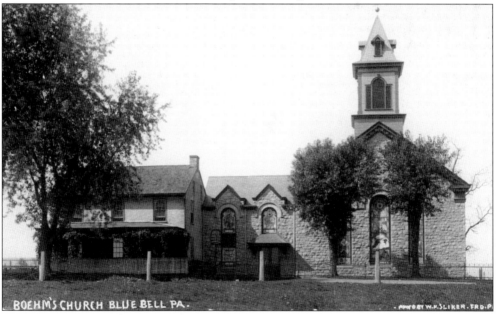

BOEHM'S CHURCH, BLUE BELL. Whitpain Township resident Rev. John Philip Boehm founded Boehm's Reformed Church in 1740. The first known building was erected *c.* 1747 and lasted until 1818. In 1818, a second church was erected; it was extensively remodeled in 1870 to resemble the church shown in this William Sliker postcard from 1907. The church and its cemetery still stand on Penllyn-Blue Bell Pike and Plymouth Road.

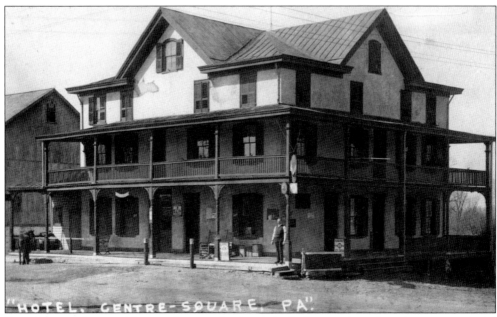

THE CENTER SQUARE HOTEL, CENTER SQUARE. At the intersection of two important colonial roads, Skippack and DeKalb Pikes, is the village of Center Square, located in Whitpain Township. The post office was established here in 1821; however, many buildings in the town were built much earlier. An early structure said to date to 1758 is the Center Square Hotel, formerly called the Waggon Inn. Thomas Fitzwater, who is associated with Fitzwatertown in neighboring Upper Dublin Township, first owned the hotel. Today this building serves as a furniture store.

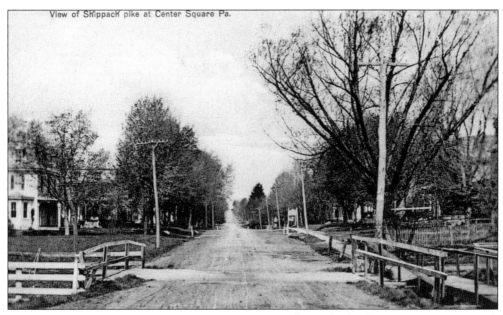

A VIEW OF SKIPPACK PIKE, CENTER SQUARE. A small wooden bridge spanning Stony Creek is seen in this 1910 view on Skippack Pike, looking west from DeKalb Pike. The village of Center Square spreads east and west along Skippack Pike. This view shows the many old buildings lining the street. A concrete bridge now occupies this site.

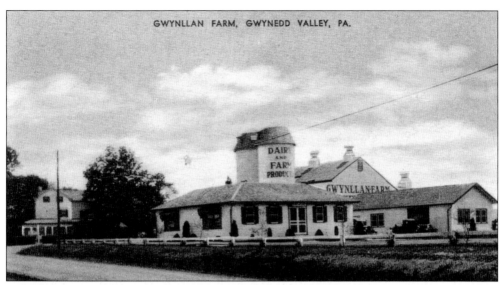

GWYNLLAN FARM, GWYNEDD VALLEY, PA.

GWYNLLAN FARM, CENTER SQUARE. Sadly, a vanishing aspect of life in eastern Montgomery County is the dairy farm. One such dairy operation was Gwynllan Farm, founded by Alexander Thayer in the 1920s. The large farm boasted a herd of dairy cows and also contained a dairy store where fresh farm products could be purchased, including the farm's own ice cream. In this *c.* 1950 view, the farm is clearly advertising its products. The farm stood along Route 202, DeKalb Pike, north of Center Square in Whitpain Township. Montgomery County Community College purchased the property in 1968. The silos and barn shown here still stand.

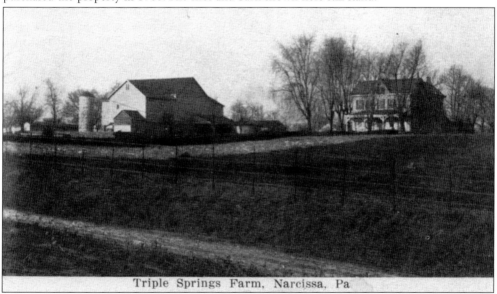

Triple Springs Farm, Narcissa, Pa

TRIPLE SPRINGS FARM, NARCISSA. Montgomery County contains many lesser-known places and villages that helped define the character of particular areas. One such place was the village of Narcissa on the border of Plymouth and Whitpain Townships. Narcissa, located at the crossroads of Narcissa and Township Line Roads, was a small village that contained a general store and, from 1887 to 1913, had its own post office. Most of the inhabitants of Narcissa were farmers, as evidenced by this 1910 view of Triple Springs Farm. This farm was north of Narcissa in an area known as Five Points. The well-known Wings Field Airport now occupies this land.

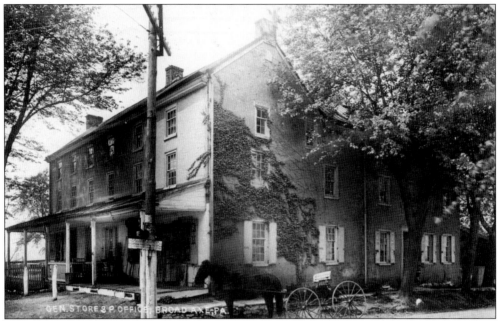

THE GENERAL STORE AND POST OFFICE, BROAD AXE. At the intersection of Skippack and Butler Pikes is the old crossroads village of Broad Axe, bordering Whitpain and Whitemarsh Townships. It was named after an old public house, the Broad Axe Tavern. The building pictured on this W. Miller postcard housed the village general store and post office. It stood across Skippack Pike from the Broad Axe Tavern. The Broad Axe post office was established in 1855 and was discontinued in 1919. This store remained through the 1920s and was later torn down. Considering the small size of the village, this store appears quite large.

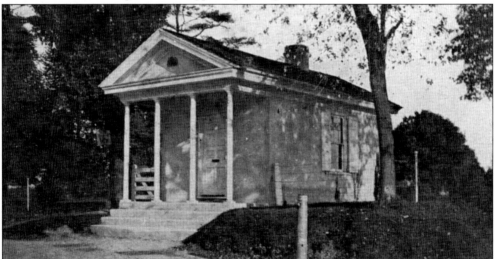

THE POST OFFICE AND LIBRARY, THREE TUNS. The village of Three Tuns was located at the junction of Butler Pike and Norristown Road and contained a general store, a hotel, and a public school. This rather unusual structure resembled a small Greek temple with its classic portico and columns. It was built by Wilmer Atkinson, owner of the Farm Journal. Atkinson lived at his estate called Northview, which was located next to this structure. The building no longer stands, and there is no longer a Three Tuns post office.

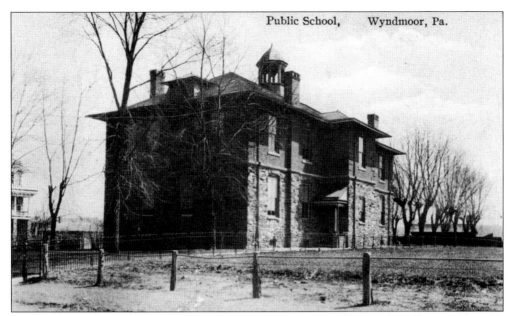

Public School, Wyndmoor, Pa.

PUBLIC SCHOOL, WYNDMOOR. Wyndmoor is a section of Springfield Township near Chestnut Hill. Wyndmoor's public school was originally built in 1893 and was enlarged in 1905 to take on the appearance shown in this 1915 view. Still standing on Willow Grove Avenue, the building has contained a private school since the mid-1960s.

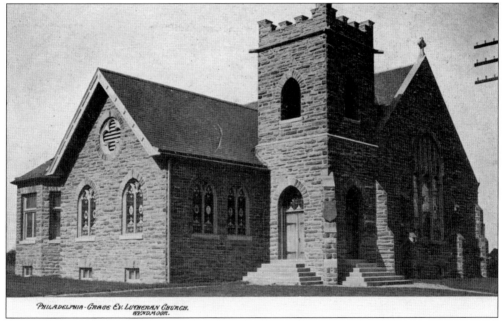

PHILADELPHIA - GRACE EV. LUTHERAN CHURCH.
WYNDMOOR.

THE GRACE LUTHERAN CHURCH, WYNDMOOR. Standing on the corner of Willow Grove and Flourtown Avenues in Wyndmoor, Springfield Township, is the Grace Lutheran Church. This World Postcard Company view from 1905 shows the church that was constructed in 1903. Alterations have been made through the years, yet the church still resembles this early view.

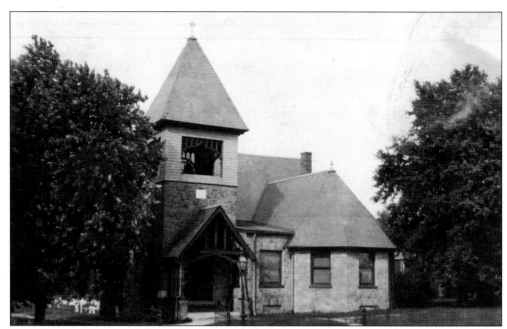

The Methodist Episcopal Church, Jarrettown. In the heart of Upper Dublin Township along Limekiln Pike is the village of Jarrettown. The year 1866 was significant for the small village. That year, the post office was established and the Methodist Episcopal church was built. The present structure, shown on this Miller postcard, dates to the 1890s and features several additions.

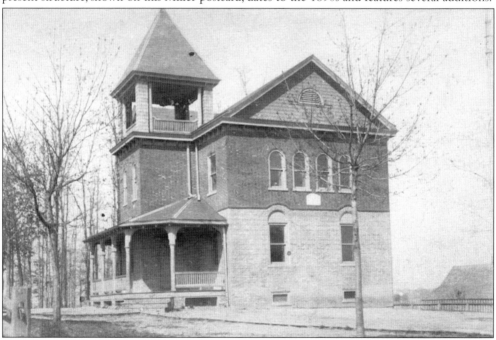

Jarrettown Public School. Jarrettown's first school was built in the very early 1800s. It was heavily damaged by the well-documented 1896 tornado that roared through portions of Ambler and Upper Dublin. As a result, this new school was built in 1896 on Limekiln Pike opposite the Methodist Episcopal church. This building, which is still standing, has been altered through the years.

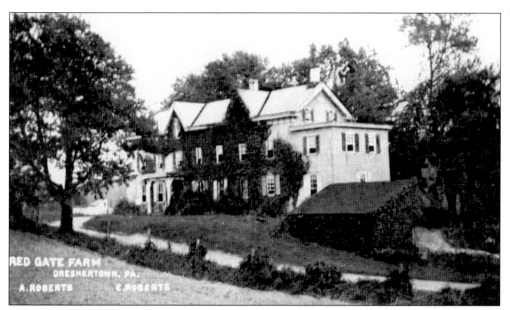

RED GATE FARM, DRESHER. Red Gate Farm is a great example of the large sprawling farmhouses that were found throughout eastern Montgomery County. Probably dating to *c.* 1800, Red Gate Farm once stood on Dreshertown Road northeast of Dresher. At the time this postcard was made *c.* 1948, the Roberts family owned the farm. The farm is no longer standing, but there is a Red Gate Drive in the vicinity of the former property.

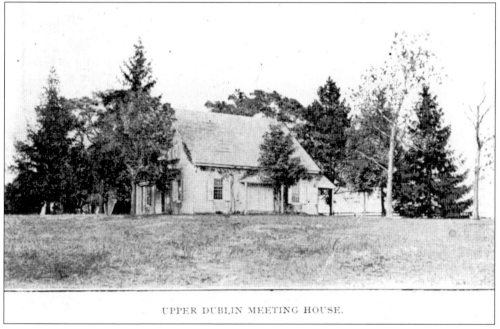

UPPER DUBLIN MEETING HOUSE.

THE UPPER DUBLIN MEETING HOUSE. Almost every major Quaker settlement in eastern Montgomery County contained a meetinghouse. Viewed here is the Upper Dublin Friends Meeting, built in 1814 on Fort Washington Avenue at Meetinghouse Road. Somewhat smaller than the meetinghouses in Horsham, Abington, and Gwynedd, this beautiful building still looks identical to this 1910 view published by the Friends Book Association of Philadelphia.

IN THE VALLEY, MAPLE GLEN. Maple Glen is an old village on the border of Upper Dublin and Horsham. Three old colonial roads converge at Maple Glen: Welsh Road (dating to 1711), Limekiln Pike, and Norristown Road. Today, not much of the old village remains, as the area has become a popular suburban community. This 1912 Miller postcard view of a bit of country scenery near Maple Glen shows a lonely dirt road in a valley. This unidentified road may be either Welsh Road or Limekiln Pike.

Bibliography

Carter, Velma Thorne. "Penns' Manor of Springfield." Wyndmoor: the Township of Springfield, Montgomery County, Pennsylvania, 1976.

Fesmire, Sylvia. *Window on the Past: A History of the Huntingdon Valley Area and Bryn Athyn.* Huntingdon Valley: the Pennickpacka Historical Society, 1977.

Lower Merion Historical Society. *Lower Merion: A History.* Broomall: Havertown Printing Company, 1988.

Rothchild, Elaine. "A History of Cheltenham Township." Cheltenham: Cheltenham Historical Commission, 1976.

Ruth, Phil Johnson. *Fairland Gwynedd.* Souderton: Indian Valley Printing, 1991.

Shaffer, Helen. "A Tour of Old Abington." 1976.

Thompson, Ray. *Washington at Whitemarsh.* Fort Washington: the Bicentennial Press, 1974.